The Spirit
of
Butterflies

The Spirit of Butterflies

Myth, Magic, and Art

Maraleen Manos-Jones

Harry N. Abrams, Inc., Publishers

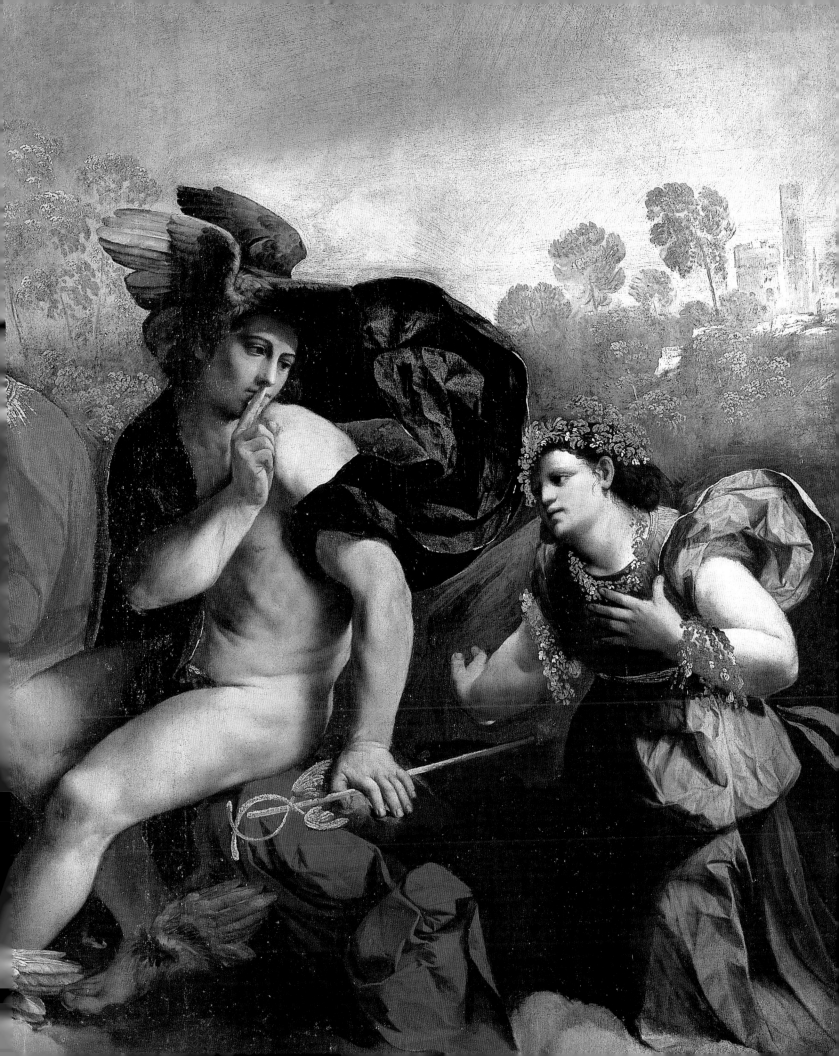

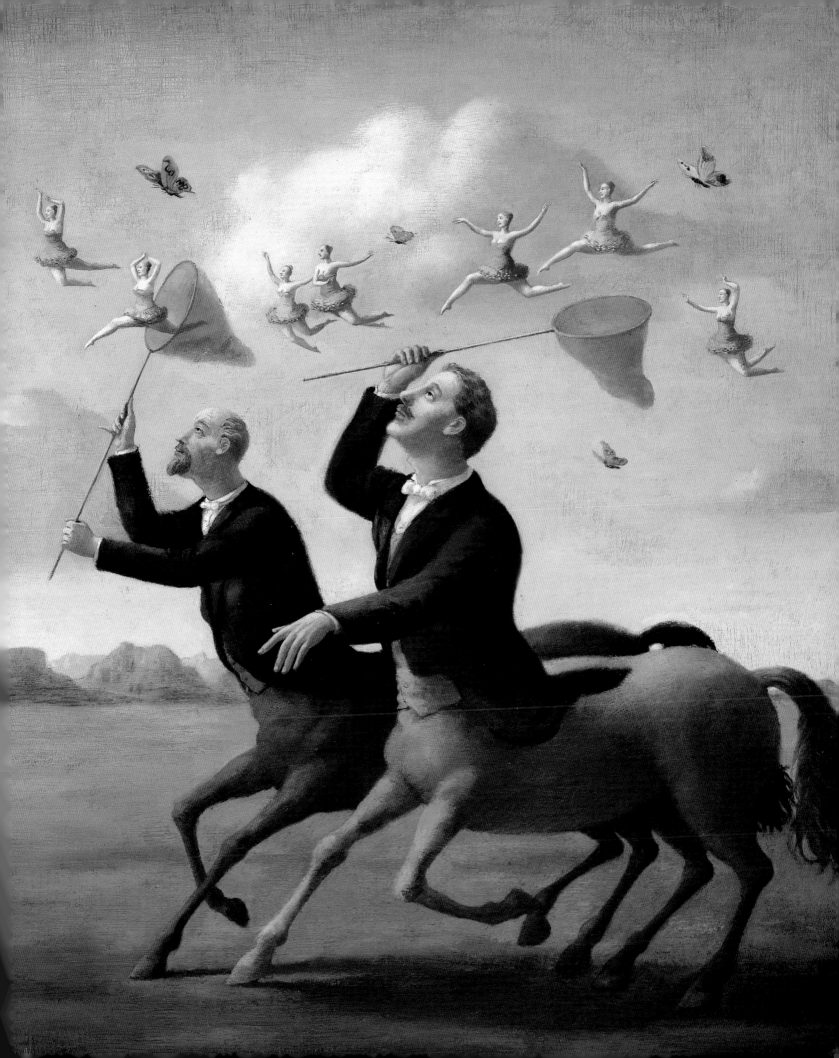

Dedicated to my mother, Anna, a bright light who always tried her best, now a butterfly.
Her spirit is with me, as is her deep and abiding love, the very foundation of my life.

Editor: Barbara Burn

Designer: Carol Robson

Library of Congress Cataloging-in-Publication Data

Manos-Jones, Maraleen.
 The spirit of butterflies : myth, magic, and art / Maraleen Manos-Jones.
 p. cm.
 Includes bibliographical references and index.
 ISBN 0–8109–4115–5
 1. Butterflies—Folklore. 2. Butterflies in art. 3. Butterflies in literature. I. Title.

GR751 .M36 2000
398' .3695789–dc21 00–28262

Harry N. Abrams, Inc.
100 Fifth Avenue
New York, N.Y. 10011
www.abramsbooks.com

Text credits are cited within the body of the book with the following exception: "La Mariposa"
by Clarissa Pinkola Estes reprinted from *Women Who Run with the Wolves.* © 1992, 1995 by Clarissa
Pinkola Estes, Ph.D. All rights reserved.

A portion of the author's proceeds from this book will be donated to Michoacan Reforestation Fund.
For every dollar donated, a tree can be planted in the buffer zones around the butterfly sanctuaries.
The local *campesinos* are being paid to plant the trees, and they are allowed to harvest some trees for
sale, thus solving a serious deforestation problem in this area. This solution offers dignity through
economic self-sufficiency to the mountain people and protection to the monarchs' hibernation area,
a sustainable answer to a heretofore-intractable problem. For additional information, contact The
Michoacan Reforestation Fund, 628 Pond Isle, Alameda, California 94501, tel. (510) 337-1890.

Page 1: Gloria Joy. *Exultation,* 1973. The artist made this picture to express her feeling of freedom at the end of a difficult marriage; for her the butterfly symbolizes the "transformation from darkness to light." Collection of the artist

Pages 2–3: Giovanni Dosso Dossi, *Jupiter, Mercury, and Virtue,* c. 1523–24. This early-16th-century Venetian painter has shown Jupiter as an artist painting butterflies. Although the meaning of the image has been the subject to different interpretations, the primary theme seems to be the art of painting. Kunsthistorisches Museum, Vienna

Pages 4–5: Ilya Zomb. *Sentimental Pursuit,* 1997. Since 1995 butterflies have been featured as a theme on the cover of *The Book,* the holiday merchandise catalogue distributed by the Neiman-Marcus store, which holds an annual cover contest to which thousands of butterfly designs and paintings are submitted each year. A detail of this intriguing picture by the Hungarian painter Ilya Zomb was used on the cover of the 1997 catalogue.

Opposite: Tamas Galambos. *Butterfly,* 1996. Private collection

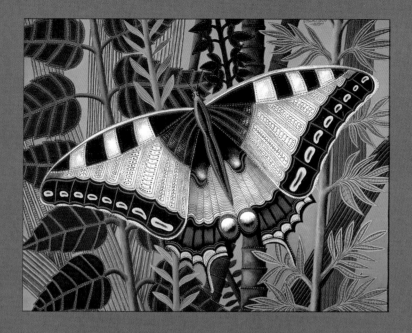

Introduction

On the mid-1960s, I had a chance encounter with a butterfly, which landed on my heart and stayed there for an afternoon in a Vermont meadow. The experience touched me deeply and reminded me of the fourth-century B.C. Chinese Taoist poet, philosopher, and mystic Chuang-tsu, whose poem of dreams and butterflies is perhaps familiar to many of you:

> *I dreamt I was a butterfly,*
> *fluttering hither and dither,*
> *to all intents and purposes a*
> *butterfly. I was conscious only*
> *of following my fancies as a*
> *butterfly, and was unconscious*
> *of my individuality as a man.*
> *Suddenly I awoke and there I*
> *lay myself again. Now I do not*
> *know whether I was then a man*
> *dreaming I was a butterfly or*
> *whether I am now a butterfly*
> *dreaming I am a man.*

Thus began my fascination with butterflies, but my passion for butterflies did not emerge until the summer of 1972 on Cape Cod in Massachusetts. I was walking with a friend looking for herbs and flowers in the woods of Wellfleet when I tripped and fell on one knee. There, a few inches in front of my face, was a fat caterpillar with yellow, black, and white stripes that waved its antennae at me in what I assumed was a greeting. I said, "Oh, hello. And who are you?" (I later found out that the caterpillar was trying to scare me away, which obviously had not worked.)

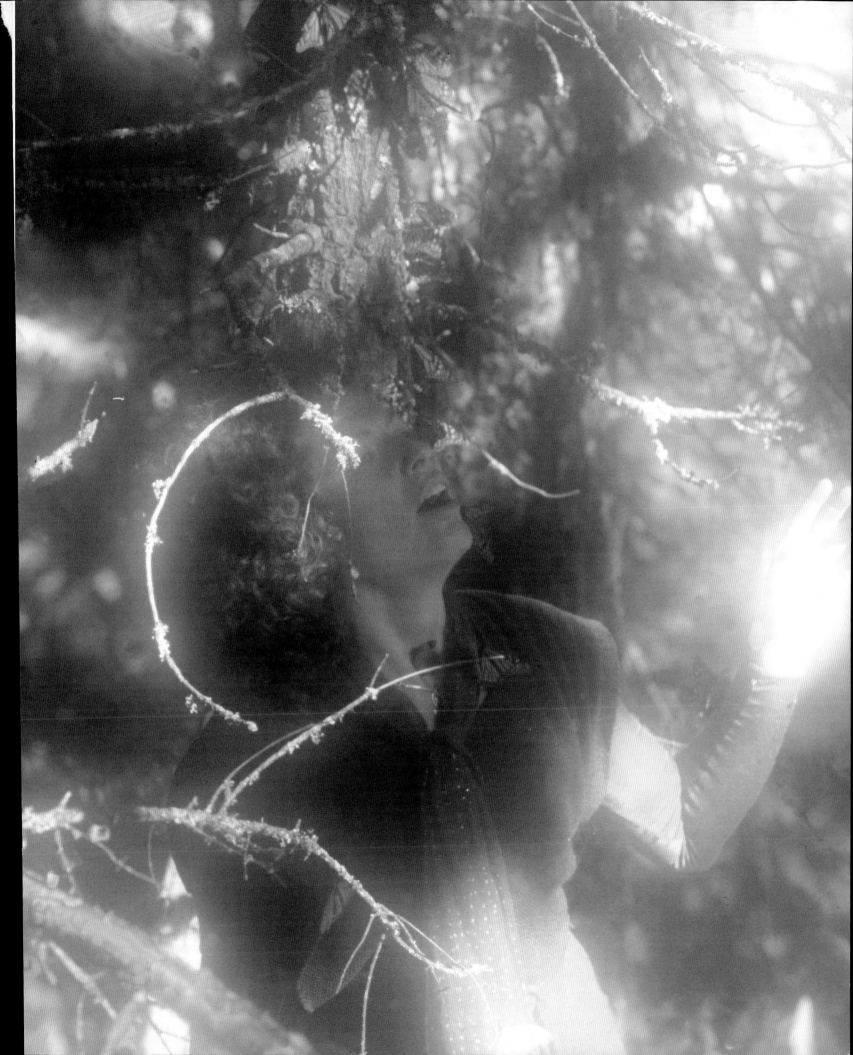

My curiosity aroused, I took the caterpillar home, together with the plant on which it was feeding, and I did some research. This caterpillar was a monarch butterfly in the making, and the plant was a milkweed. I was thrilled to be able to witness the drama and beauty of metamorphosis firsthand. For those who have not seen a metamorphosis close up, let me share the experience with you.

I brought fresh milkweed to my new caterpillar friend every day to satisfy its voracious appetite. It ate (and excreted) so much during the next ten days that it shed its skin four times. The fat caterpillar then attached itself to a milkweed branch with a silky substance, which it spit out of a gland under its mouth. The creature wriggled till its rear end reached the silky glob, and then it stuck a hook, or cremaster, deep into the silk button and continued to wriggle until the hook was secure and the silk held the caterpillar to the branch.

Slowly, hesitantly, the caterpillar released itself from the branch, using each pair of its succeeding eight legs, starting with the front pincers. It finally swung upside down in a **J** shape (reminding me of the yogic shoulder stand), a process that took twenty minutes, and it stayed in this position for about twenty-four hours.

Suddenly the antennae went limp. The caterpillar seemed to be suspended, dangling upside down, and its skin became pale and opened up, as if it were being unzipped from the back of the head all the way down to its toes. Then the caterpillar started a spiral dance, swirling and gyrating until the skin was worked all the way off the back. The layer beneath the old skin was a glistening, luminescent springtime green in color with a kind of white glow about it. The pulsating spiral dance continued, and within an hour the figure had compacted itself into an inch-long chrysalis, a gem with gold dots. (The word *chrysalis* derives from the Greek *chrysos*, meaning *gold*.)

Two weeks later this extraordinary jewel turned silvery translucent, and again forgoing sleep, I waited in anticipation for the next stage, which I knew would be the emergence of the butterfly. The gold dots seemed to have been absorbed into the body of the butterfly, and I could see the orange and black wings curled and folded within the frosted form of the chrysalis. At dawn, I felt the time was near, and I sat watching breathlessly as the transparent casing opened to reveal a fat-bodied, shrivel-winged creature, which immediately began pumping its body, forcing liquid protoplasm into its wings. Within fifteen minutes, a full-sized monarch butterfly moved onto my hand and feasted on honey and water.

We got to know one another over the next few days, while a hurricane raged outside my little wooden house by the sea. She (for I am certain she was a female) continued to drink honey and water from my hand, walked all over me as she stretched and flexed her wings, lingered on my shoulders and on my forehead, resting between my brows.

After the storm abated, the time arrived to set her free. This delicate life had ahead of her a journey of thousands of miles to a place she had never been but to which she was compelled to go. I knew from what I had read that she was going to fly to the mountains of Mexico, exact destination unknown. Reluctant to leave, she returned to land on me several times, but finally she took flight, soaring and dancing with the wind.

One week later, in the quiet of early evening, I heard a strange sound. Scores of minuscule black, yellow, and white striped caterpillars were noisily eating the milkweed plants I had gathered for my first caterpillar. I had not realized that butterflies lay their eggs on the underside of the host plant, and as I had gathered more milkweed, I had inadvertently collected more caterpillars. More than a hundred butterflies emerged in my little house that first summer.

Valley of the Butterflies, Mexico

From that summer in 1972 until now, I have raised and released butterflies, no matter where I have lived, even in New York City, but the individuals whose emergence I actually witnessed always seemed to establish an especially close relationship with me, flying back to me as the others flew off. Not until the winter of 1977 did I feel compelled to follow my dream of going to Mexico looking for the mysterious, ultimate destination of the monarchs. Knowing only the altitude and the type of tree in which the monarchs roosted, I spent two months climbing on horseback and on foot, exploring the peaks and valleys of the Sierra Madres. I faced many challenging moments, both physical and spiritual, before encountering the hibernation grounds of the monarchs, where I saw 50 million butterflies mating on the first day of spring. The adventures of that journey will be detailed in my next book, *In Search of the Butterflies*. Some of the teaching stories, myths, and legends I encountered along the way are shared here.

Although I consider myself a butterfly collector, I don't kill butterflies and put them under glass or plastic. I have searched for them and lived with them, and I have always had a butterfly garden to attract them. Mostly, however, I have been transformed by them. I once choreographed a dance about them, and I have created butterfly goddess clothes, and owned a gallery, Chrysalis—A Place for Dreamers. I have written and performed and lectured about butterflies; I have also collected butterfly myths, poems, art, and artifacts. I have found stories and stories have found me. Friends never wonder what gifts to give me, since I have been known these past thirty years as the Butterfly Lady.

All over the world, in all cultures throughout history, from ancient times until the present, the metamorphosis of this special life form has been a source of wonder. Many cultures have given a special significance to this process, perceiving it as a symbol for their varied belief systems. Many similar myths about butterflies have arisen in very different cultures that are representative of renewal, transformation, death, and rebirth or resurrection, awakening, consciousness, courage, love, joy, and hope. Their infinitely varied patterns have inspired artists for many centuries, and butterflies continue to appear in art, poetry, and myth; butterfly images have even become a major inspiration for designers and an important presence in popular culture. Everywhere I look butterflies appear in diverse guises, and I know that many people share in my passion for them.

What is this special fascination all about? There are a number of reasons, I'm sure, but my strong feeling is that we need butterflies to remind us that positive change is possible, that there is magic to life, and that we have to be mindful of our surroundings, because if we destroy nature, we destroy ourselves. Butterflies awaken our spirits and open our hearts. They give us a sense of hope and the possibility of our own transformation and evolution.

It is with this hope that I present the myths, legends, stories, poems, anecdotes, and art from many different cultures through the ages, each reflecting the spirit of the butterfly to touch, awaken, and hasten no less than a planetary evolution.

No written records exist to describe or explain the beliefs of our Stone Age ancestors, but archaeologists have managed to piece together aspects of their lives from the art and artifacts they left behind. Paintings and sculptures created more than 25,000 years ago indicate that the human impulse to create recognizable images and meaningful patterns has long been with us, and animals were among the most commonly recurring subjects in these works. One of the oldest depictions of a butterfly occurs in a wall painting in a religious shrine excavated at Çatal Hüyuk on the Anatolian plateau (present-day Turkey), dating from about 6500 B.C. Schematic butterfly forms and chrysalis shapes have also been found on dishes made in central Europe as early as the fifth millennium B.C. Many early butterflies appear near pictures of bulls, one of the most potent prehistoric symbols, probably in connection with regeneration, or the transformation from death to life. This connection may have been made as flying insects were observed emerging from the decomposing bodies of sacrificed bulls, but it also seems clear that humans understood the life cycle of the butterfly and were able to relate these phenomena to their own lives.

Although some scholars have drawn parallels between the butterfly's chrysalis and the Egyptian practice of wrapping mummies in preparation for the afterworld, butterflies seem not to have been an important symbol in the religions of ancient Egypt, where the scarab beetle was the primary symbol of rebirth. Butterflies were sometimes represented in tomb paintings depicting scenes of life along the Nile, presumably as one of the pleasures that awaited the deceased in the afterlife (see page 34), and a few pieces of Egyptian butterfly jewelry have been found in tombs, but these were probably influenced by Minoan art, in which the butterfly played a major role.

The late Marija Gimbutas, a professor of archaeology at the University of California, Los Angeles, combined the study of mythology, history, ethnography, and language to establish a powerful case supporting the existence of goddess worship in early European culture. She connected many symbolic images to the cult of the goddess, and the butterfly

OPPOSITE, BOTTOM LEFT:
This reconstruction of a Minoan wall painting from the palace at Knossos was put together from a number of unrelated fragments, and scholars still don't agree whether this is a priest, a prince, or a dancer paying homage to a supreme goddess. Although the authenticity of lily crown and even the lilies themselves have been questioned, the beautifully schematized butterfly is definitely an original part of the wall decoration at Knossos.

RIGHT:
The geometric forms that appear in the circles on this dish excavated in Thessaly and dating to the late fifth millennium B.C. are butterflies, which were very early symbols of becoming or transformation.

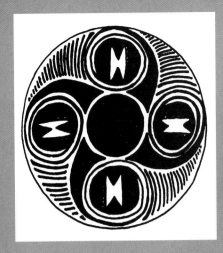

RIGHT:
These butterfly images appear on plates found in central Europe that also date to the fifth millennium B.C.

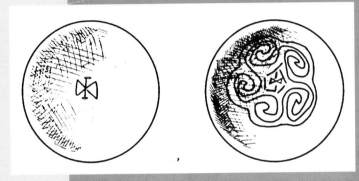

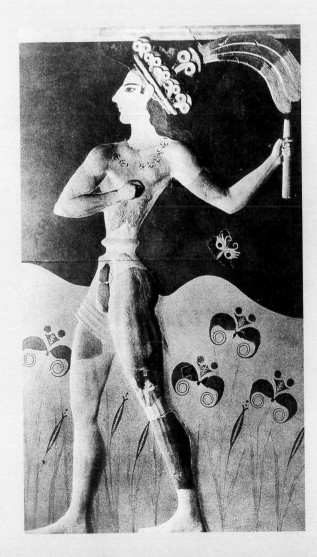

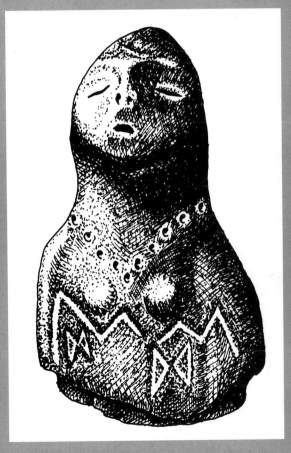

ABOVE:
Butterflies, probably symbols of regeneration, appear beneath the M shapes below the breasts of this Italian Neolithic figurine of c. 5300 B.C.

The double-axe-shaped butterfly, in a highly schematic, abstracted form, appears as a major motif on the lips and in the central panel on this Mycenean vase of c. 1500 B.C.

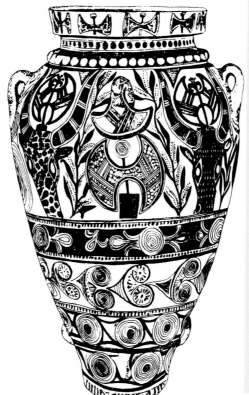

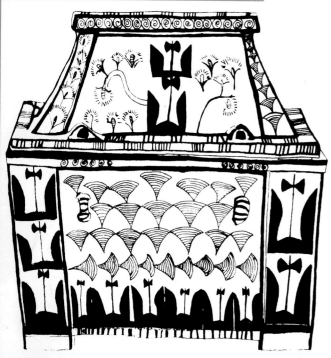

The carving on this late Minoan sarcophagus of c. 1300–1100 B.C. from western Crete incorporates a number of symbolic motifs, including butterflies, which rise between the horns of bulls to declare the triumph of life over death.

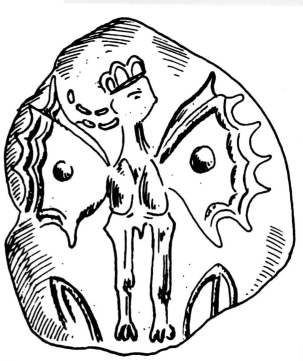

This seal impression of c. 1700–1670 B.C. from eastern Crete portrays a goddess with the wings of an eyed butterfly, a common species of the area.

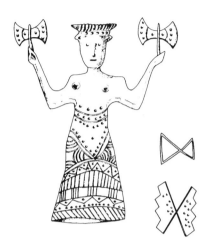

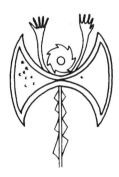

was one of them, especially among the Minoans. This Aegean people established a sophisticated civilization on the island of Crete during the second millennium B.C., but the modern world knew little of their culture until the nineteenth-century archaeologist Sir Arthur Evans discovered and excavated the palace complex at Knossos. This was a vast site on which many buildings, including a palace of double axes, had been constructed over the years, the most recent about 1900 B.C. Known to the later Greeks as the Labyrinth (derived from *labrys,* or double ax), the palace was said to have been a maze in which the legendary King Minos kept the Minotaur, a bull-man monster. Although the bull image is dominant in Minoan art, the butterfly also appears in many different forms, probably symbolizing the principle of transformation and rebirth. Butterflies can be found emerging from the heads of bulls in designs painted on vases and carved on sarcophagi in celebration of the triumph of life over death; they were combined with human forms to create winged goddesses.

Most interesting is the coupling of the schematic butterfly form with that of the double ax, perhaps one of the most pervasive Minoan patterns. In the context of its use by the female goddess figure, the double ax appears not to be an aggressive weapon but a sacred object, and scholars have suggested that the visual similarity between the shapes of the double ax and the butterfly and the link between the butterfly and the bull (whose head and horns resemble the shape of the human uterus and fallopian tubes) account for the spiritual connection between these images and the notion of birth and renewal. The schematic butterfly–double-ax form can also be found in later Mycenaean and Greek art, where it becomes more abstract and geometric, although it is possible to detect in Greek art elements of butterfly species of the Aegean region, such as the common white butterfly with its distinctive "eyed" wings.

The butterfly goddess was not among the pantheon of Greek and Roman deities, for whom the butterfly symbolized the human soul (see page 32), but the stages of the butterfly's life cycle were seen by early Christians to correspond to the three stages of the life of Jesus and, by extension, of Christians. The lowly caterpillar represents our earthly selves, our preoccupation with the physical plane of existence, although it contains all the elements needed for metamorphosis. In the fifth century, Pope Gelasius I issued a pontifical decree declaring that Christ was a caterpillar, for not only did he humble himself and was humbled, but he was also resurrected: *Vermis quia resurrexit* (The worm [caterpillar] has risen again). The chrysalis represents the tomb, the place where the miraculous resurrection takes place, from which the soul rises, and the beautiful, free-flying butterfly, of course, symbolizes Christ's spirit reborn. Even today, in the west of France, the Cleopatra butterfly, which appears in early spring, is called the Easter Jesus.

Myth

When the Gods first arrived in Mexico they were guided by the flight of the butterflies. The butterflies came from the direction of the north, along a route full of flowers and fruits. Both the butterflies and the Gods came to the same place by the same route. At this time day did not exist, all was night. When all the Gods gathered, they asked, "Who will light the world?" A God named Fecuzistecatl boldly said, "I will undertake this task. I will light the world."

The Gods conferred again. "Is there anyone else who wishes to do it?" Everyone remained silent until at last the God Nanahuatzin offered himself. After this, the Gods lit a huge and very hot bonfire, the smoke and the flames from which drove the snakes to the pitted bottom of the earth.

The Gods said, "Jump into the fire," but Fecuzistecatl was afraid of the pain. Indignant that there was no light, the Gods turned to Nanhuatzin and commanded him to jump into the flames. Nanhuatzin closed his eyes and threw himself on the fire without hesitation. Upon seeing this, Fecuzistecatl then threw himself on the bonfire. The Gods sang and the day began to turn red. Light began to shoot forth toward the sky, and everyone knelt down to await the appearance of Nanhuatzin changed into the sun and Fecuzistecatl changed into the moon. It was never again dark in the world.

The Gods conferred again. "And now with what will we adorn this light which has arrived in the world? The light requires colors," they said. "Who wishes to adorn the earth?" they asked. All looked at each other and Quetzalpapalotl, said, "I will do it." And he drew with his own life many lines and points of color in space and gave himself the plumed wings of a butterfly. Thereafter he became known as the Plumed Butterfly. The Gods insisted, "But your life will not last long since you have turned it into color." Quetzalpapalotl responded, "It doesn't matter. I will not disappear when I die. I will fall from the sky which I adorn and adorn the earth as well." And so it happened, he flew away into space and fell from the sky to the earth. Where there was emptiness, there were now flowers and butterflies of every color. And this is how the world was prepared for man.

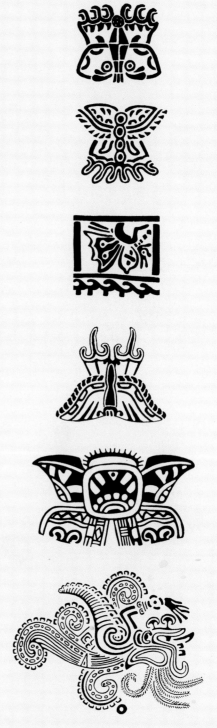

These butterfly patterns, which are impressions of clay stamps, were probably used to decorate pieces of ancient Mexican pottery.

Most of what we know about the religious life in ancient Mexico has resulted from the study of ancient sculptures, temple buildings, and sacred texts, or codices, found in the sixteenth century by the Spanish, who managed to destroy much of what they found. The few codices that survived now serve as invaluable sources of information about Precolumbian divination, religious ceremonies, the ritual calendar, and mythology, presented in a combination of pictographs, ideograms, and phonetic symbols. The codices of central Mexico reveal that the Aztecs had absorbed a great deal from the people who had previously dominated the area, including the Olmecs, Toltecs, and Chichimecs.

The early Mexicans closely observed and meticulously studied the natural world. They were especially fascinated by butterflies and used them in many sacred contexts, from objects of adornment to religious stone carvings. Along with snakes, butterflies were the creature most frequently represented in a spiritual sense in Precolumbian Mexico and in fact have been the subject of an entire book, painstakingly compiled by the Mexican scholar Carlos R. Beutelspacher in 1988. It cannot be coincidental that Mexico is also a place where more than a thousand species of lepidoptera make their home. Deep in the heart of the Sierra Madre, Mother of Mountains, there is a sacred place where migrating monarchs have come for millennia to rest, gather, hibernate, and mate, although there is no evidence that the early Mexicans were actually aware of this phenomenon.

There are two Spanish words for butterfly. *Mariposa* derives from *la Santa Maria posa* (the Virgin Mary alights). Some Mexicans tend to prefer the second word, *papalote*, which is derived from *paplotl*, meaning butterfly in Nahuatl, a Toltec language still spoken by about one million Mexicans. (*Papalote* also means kite and now refers to hang-gliders, which are very popular in the mountains of Mexico.) The Nahuatl word for the egg of a butterfly is *ahuaupapalotl*, which also means seed of happiness.

The Mexican butterfly species *Itzpapalotl* is also known as the obsidian butterfly or the butterfly of four mirrors; scientists know it as *Rothschildia orizaba* of the Saturnidae family. The word *Itzpapalotl* is derived from the Nahuatl words *itztli*, meaning obsidian, and *papalotl*, meaning butterfly, and is also the name of a Chichimec goddess, known as the Obsidian Butterfly Goddess of Four Knives. The patterns on the wings of this butterfly are similar to the shape of the blades used in sacrificial rites that were made of obsidian, a hard substance born of volcanic fire. This ancient poem about Itzpapalotl was recorded by the Spanish priest-ethnographer Fray Bernardino de Sahugan, who transcribed in Nahuatl and Spanish traditional texts from native wise men shortly after the Conquest.

The Goddess is upon the rounded cactus:

She is our Mother, Obsidian Butterfly.
O, let us look upon Her.
She is fed upon stag's hearts in the Nine Plains
She is our Mother, Queen of the Earth
With fresh marl, with fresh plumage is she clad.

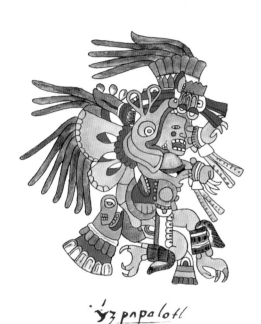

ýz papalotl

A depiction of the mythical goddess Itzpapalotl, the Obsidian Butterfly Goddess of the Four Knives from the Telleriano-Remensis Codex

RIGHT:
The butterfly of the Mexican species Rothschildia orizaba, *known as the obsidian butterfly*

When the Aztecs conquered the Chichimec people in the fifteenth century, they absorbed into their religion many earlier gods and goddesses, including Iztpapalotl, who had apparently existed for many hundreds of years. Butterflies were often depicted on Toltec and Aztec warriors' shields. Some may refer to Itzpapalotl, who is said to have been a protector of warriors, but they may also refer to Xochiquetzal, the goddess of love and companion of the fire god. It was she who followed young warriors onto the battlefields and made love to them while holding a butterfly between her lips, to give them courage and to reassure them that their souls would be transformed if they had to give their lives in battle.

Xochiquetzal, whose name comes from *quetzalli,* meaning precious, and *xochitl,* meaning flower, was also known as Xochiquetzalpapalotl, flower of the precious paradise butterfly. She was the goddess of artists who presided over penitence, and temples were dedicated to her in Tenochtitlán near the Great Temple in the center of Mexico City, where the Spanish built a cathedral of the old temple stones in an effort to obliterate Aztec religious and philosophical beliefs. The Catholic religion, however, absorbed

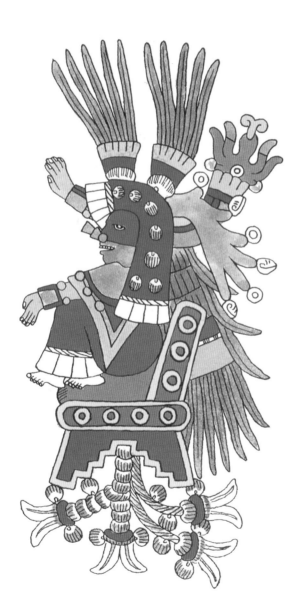

LEFT:
An image of the goddess Xochiqueztal, symbol of fire and water and the mother of Quetzalcóatl. From the Borbonico Codex

The *Xochiquetzal butterfly* (Papilio multicaudatus)

many of them, just as the Aztecs had absorbed the cultures that preceded them, and even today, the gods and goddesses of ancient Mexico continue to hold power. Legend has it that Tenochitlán was founded, in 1325, when an eagle with a snake in its mouth landed on a cactus, an image that is still an important Mexican symbol, appearing on coins, government buildings, museums, aircraft, and churches.

Xochiquetzal was especially revered as the mother of Quetzalcóatl, the God of Life, the Lord of Dawn, who was said to have given birth to humankind. This legendary Toltec ruler was widely revered as both a god and a great leader, and his influence spread to every corner of the Mesoamerican world. Quetzalcóatl was opposed to war and human sacrifice and instead offered the gods tortillas, incense, butterflies, snakes, and flowers. When he died, his form is believed to have gone into a larval stage, when he became known as Xolotl, who was reborn as the Morning Star, which contained the seed of spirit capable of life after returning from death. This theme is represented in frescoes painted at Teotihuacán, the site of the ancient pyramids outside of Mexico City that predate even the Olmecs and Toltecs. Here the famous Pyramids of the Sun and the Moon are accompanied by a smaller Temple of the Butterflies, and this is where the roots of the ancient Mexican spiritual beliefs have survived in various forms to this day. According to Aztec legend, warriors at death joined the sun, the reborn Quetzalcóatl, and after four years were reborn as hummingbirds or butterflies, which then escorted the sun to its zenith.

Xochipilli, God of Flowers, is the personification of the soul, which is represented by a butterfly. It is said that the flowers of Xochipilli are really dream flowers, otherwise known as sacred mushrooms. Xochipilli sees with the eyes of the soul, and his expression is often depicted as one of ecstasy, possibly induced by hallucinogens. All around the base of his statue mythic butterflies sip nectar from mushrooms, not a common occurrence in nature, but here a symbolic image of the food of the gods, for they are carved onto Xochipilli's knees and right forearm and on top of his head. Sacred mushrooms are said to shift consciousness, guide visions, and open the door to other realities. This song to Xochipilli appears in the Matritense Codex of the sixteenth century:

Festive songs, painted of flowers
Come freely, come unfolding: listen to it!
To be among butterflies and in the watery moss of your house
Songs of illumination and becoming.

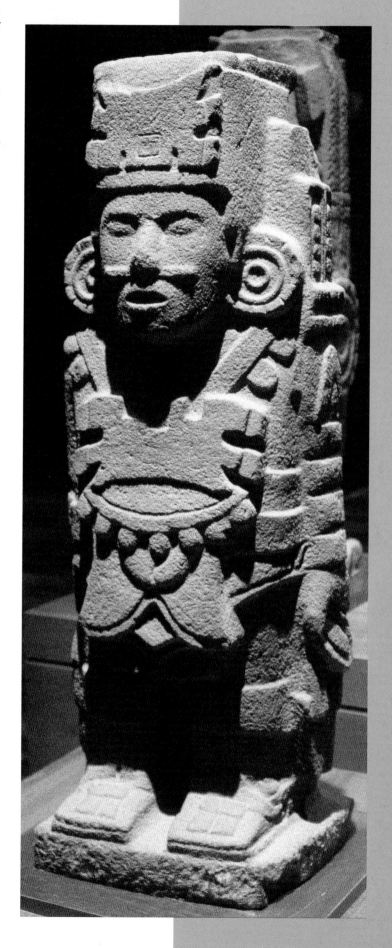

A carved butterfly form is visible in the pectoral of this stone Toltec warrior.

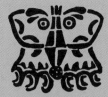
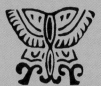
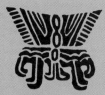

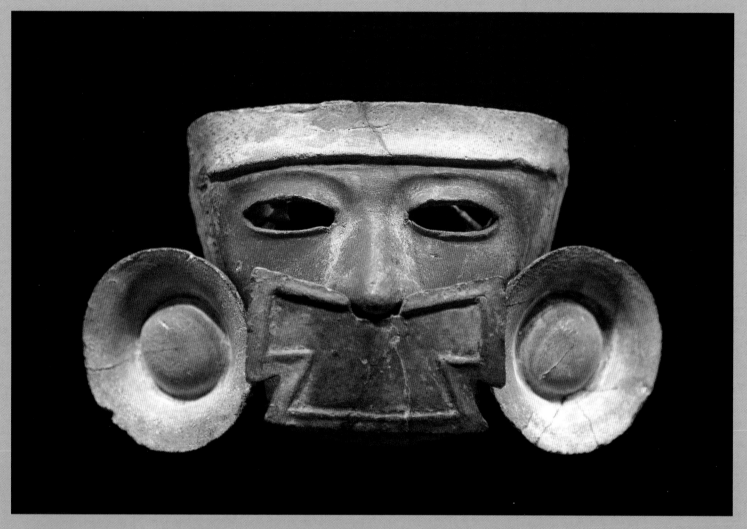

ABOVE:
A mask of the god Xochipilli

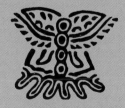
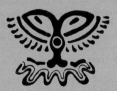
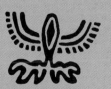

The seal impressions on this page are abstracted butterfly shapes based on the paradise butterfly named for Xochiquetzal.

In Mexico, as in other ancient cultures, the butterfly has been associated with fire, and the two images are combined in the outer rings of the Aztec calendar. Fire and butterflies are symbolic of transformation: in order to achieve understanding of our inner light, we have to walk through the fires of our souls. Butterflies and fire do not seem to have much in common, except in the similarity between the movement of colored butterfly wings and the flickering of a colorful flame, and it is possible that the moth's attraction to flame may also be related to this age-old association. Butterflies also appear in depictions of the god of fire, Tlaloc, who reigns over Tlalocán, an earthly paradise on the slopes of Popocatépetl, a volcano in Malinalco. Vases and frescoes from Teotihuacán show Tlaloc in a pool of water, surrounded by butterflies. This vision of earth as paradise is based on the concept of the balance or harmony of fire and water, the unifying principle of opposites, not unlike the Asian concept of yin and yang.

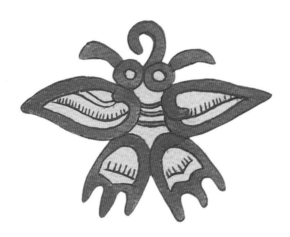

This image of a butterfly is based on a Tlaloc mural at the Temple of the Butterflies at Teotihuacán.

The Mexicans were not the only Mesoamericans to have chosen the butterfly as a sacred deity. The Kuna Indians of the San Blas Archipelago along the Panama coast have maintained their matriarchal society for about three thousand years, and their traditional goddess-centered belief system has survived in the form of the Giant Blue Butterfly Lady, who is the holder of the seed of the Kuna religion and retains the great mysteries of life and death from the ancient times. The blue morpho butterfly, with its graceful, gliding, iridescent wings, represents this Earth Mother, whom the Kunas still worship.

This embroidered mola is typical of those made by the Kuna Indians of Panama in that it is constructed of layers of different-colored fabrics cut in patterns to reveal the color underneath and includes the image of a happy butterfly. Collection of the author.

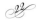

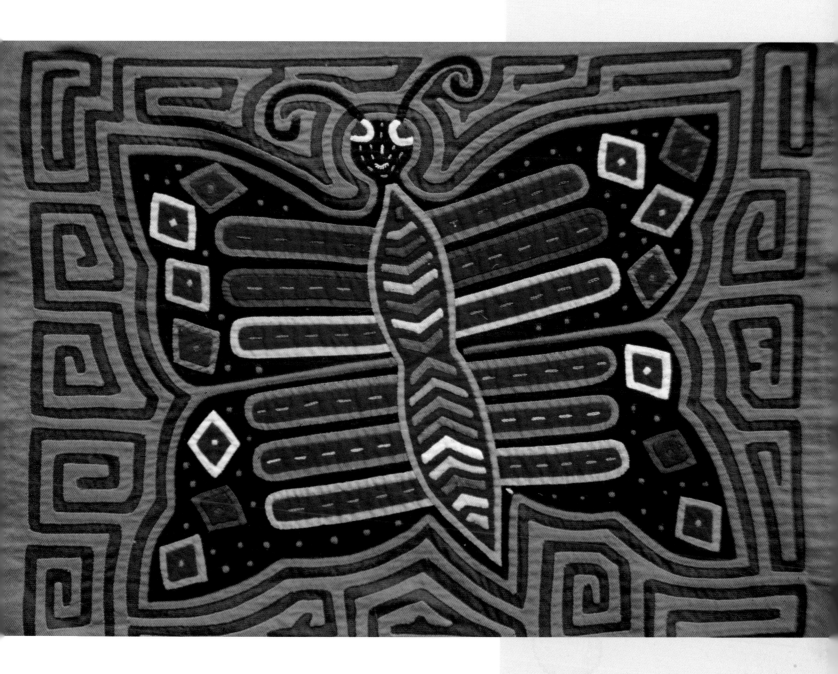

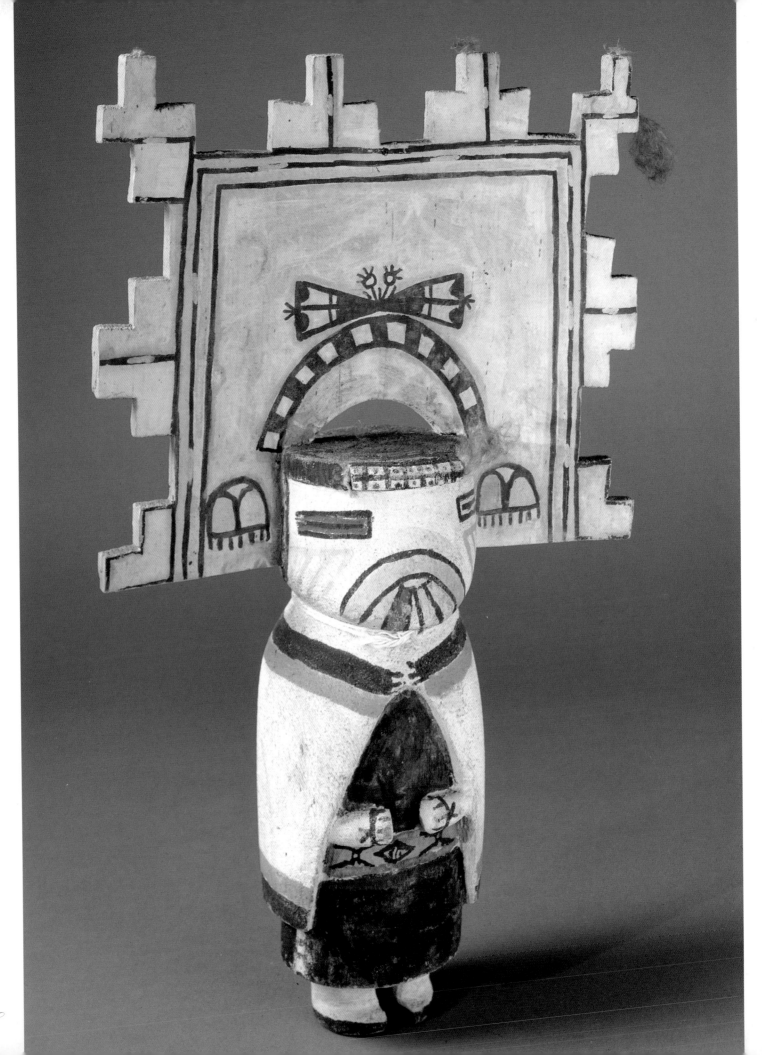

In the many different worlds of the American Southwest, butterflies and moths have played and still play a part in Native American religious belief and ritual. For many peoples the butterfly represents the soul of the dead—the rebirth, renewal, and awakening of the spirit. In Pima mythology, the butterfly is one form of the creator whose name is Chiowotmahki, who flew over the world until he found a suitable place for man. Like the Aztecs, the Arapaho Indians of North America associate the morning star with the butterfly, which represents the soul of the dead. After the end of night, which is equated with death, a bright light appears in the sky, showing that the spirit of the departed lives and shines on.

For the Hopis, the butterfly is a totem of the Butterfly clan, which has its own dance, *bulitikibi*. The spirit of the butterfly is personified in three of the Hopi kachina figures, which represent the spiritual essence of everything in the real world and mediate between this world and the next. The butterfly kachinas are Poli Taka, butterfly man; Poli Mana, butterfly girl, and Poli Sio Hemis, a Zuni butterfly kachina. During sacred dances, the Poli Takas give carved replicas of their kachina to women and children. Butterfly symbols are also an integral part of the "woven pottery" of the Hopi. The thirteen diagonal lines on the ceremonial basket shown below represent lightning surrounded by snow clouds and are symbolic of the connection between heaven and earth. The butterfly detailed on the right represents the Butterfly clan, which is part of the Badger tribe. It is interesting to note that the butterfly representation on the basket is a variation of the double ax of the Minoan butterfly goddess. On other baskets, schematic crosses represent flocks of butterflies arriving to announce that spring is on its way.

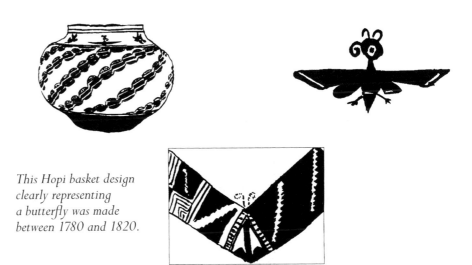

This Hopi basket design clearly representing a butterfly was made between 1780 and 1820.

Asia is a continent rich in species of butterflies, especially from the Himalayas to south-east Asia and the islands of the South Pacific, and beliefs about the power of butterflies abound, many of them with sacred connotations. People in Bangladesh, like the Hopi, believe that the many-colored butterflies bring spring with them. If a golden butterfly visits a home, that means someone in the family will soon be married. Although a butterfly on a greeting card for the New Year means the year will bring happiness, a swarm of butterflies is considered unlucky, as some disaster will follow their appearance.

Like the ancient people of the Mediterranean, the Chinese observed the metamorphosis of caterpillar to butterfly and gave it a spiritual interpretation, with the caterpillar representing our earthly, material selves and the butterfly a symbol of the reward of a heavenly afterlife, the freedom and joy that await after our earthly work is fulfilled. In China butterflies are known as *hu dieh,* or stemless flowers, and they have appeared in works of art through the ages, not simply for their decorative qualities but also for their value as sacred beings. Butterflies live in many traditional legends and fairy tales, symbolizing not only immortality but also eternal love, joy, and leisure. A Chinese emperor of the Ming dynasty is said to have used butterflies to select his true love by releasing several in the presence of some beautiful young women.

These graphic Korean butterfly ornaments contain permutations of trigrams that make up the hexagrams for reading the *I-Ching,* a book of mythical antiquity and profound philosophy about every aspect of life. It is said that the seasoned wisdom of thousands of years is contained in this venerable text, in which Confucianism and Taoism have roots and which offers insight into the thinking of the mysterious sage Lao-tzu.

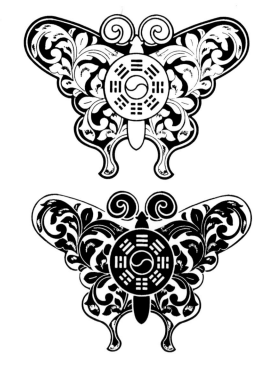

This butterfly design was used as an ornament on a Korean chest in the late Chosen Dynasty (1392–1910).

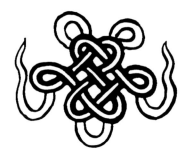

This schematic design depicts what in China is known as the mystical knot, also known as the butterfly knot.

*This beautiful Balinese
kite resembles a butterfly
alighting on a tree.*

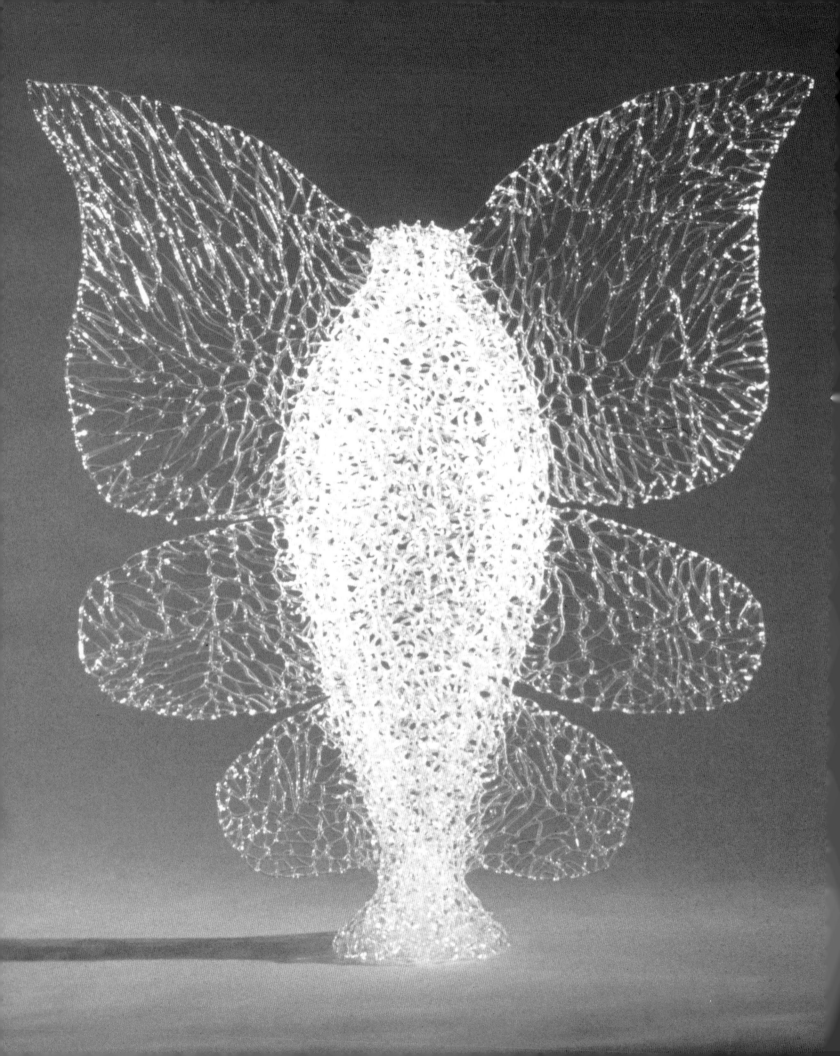

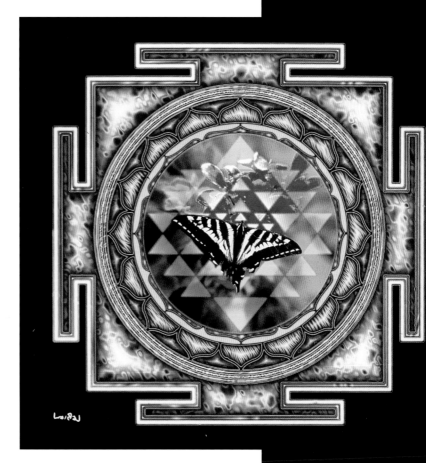

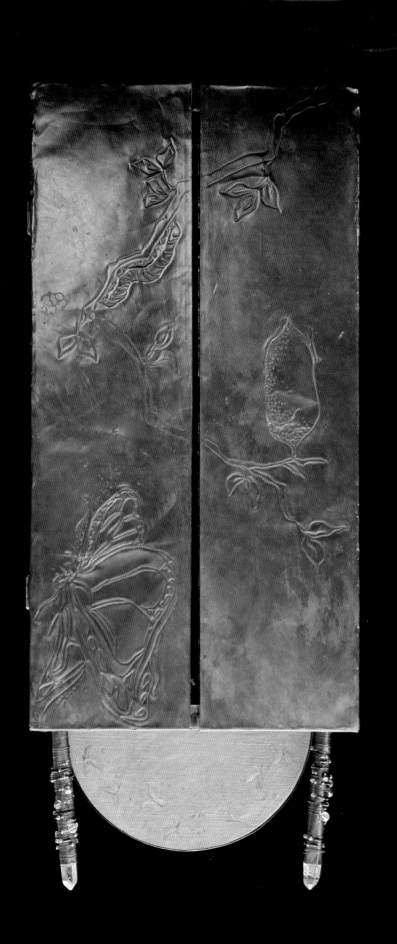

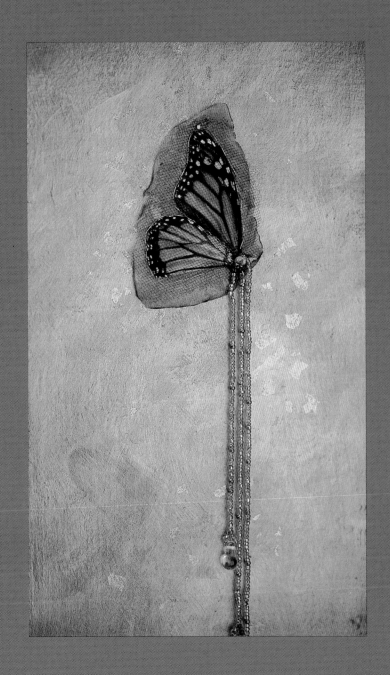

OPPOSITE AND ABOVE:
Rose Frances. Butterfly Altar, Golden Flight, *1987.*
The artist was moved to create this unusual work
by a walk through the woods with a friend
recovering from cancer. Suddenly, they were
surrounded by butterflies and felt blessed, as if
they were part of a miracle. The box is painted
wood with incised copper, topped with quartz
crystal and beads; the doors are stitched butterfly
wings and beads. The materials she used to make
the altar bag are wool and silk with embroidered
and embedded beads, leaves, moss, and butterfly
wings. Collection of the artist

The Butterfly Soul

You are like my soul,
a butterfly of Dream.

— Pablo Neruda

German archaeologist Heinrich Schliemann, who pioneered the modern study of Aegean culture, found gold beads in the form of chrysalises in tombs at Mycenae dating to about 1500 B.C., complete with eyes, wing cases, and articulated abdomens, as well as butterfly forms embossed on plates. These finds led him to conclude that for the Greeks the butterfly represented the immortality of the human being, which was confirmed by the fact that Aristotle, the father of natural history and the author of *Historia animalium*, written in 344 B.C., gave the butterfly the name *psyche,* the Greek word for soul. The Greeks seem to have believed that the soul flew out of the mouth at death, an event occasionally pictured on carved sarcophagi as a butterfly emerging from a chrysalis. The butterflies in the fresco on page 34, from an Egyptian tomb dating to the reign of Amenhotep III (1390–1352 B.C.) surround the deceased, a scribe named Nebamun, who is depicted catching birds in the marshes of the Nile along with his wife and daughter. The butterflies were presumably one of the pleasures that awaited the deceased in the afterlife, reflecting the Egyptian belief in the immortality of the human soul.

This identification of the butterfly with the human soul continued throughout the Roman era, eventually becoming absorbed into Christian symbolism. A mosaic found in the ruins of Pompeii, which was destroyed in the first century A.D., depicts a human

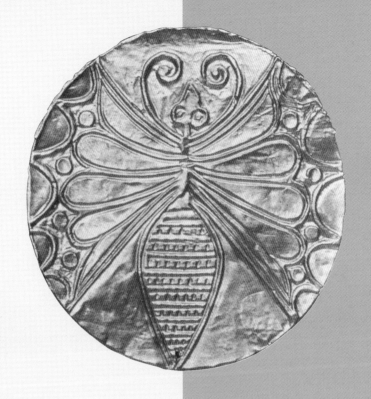

Mycenaean gold roundel, c. 1550–1500 B.C. National Archaeological Museum, Athens

This image of a butterfly rising from a skull, which appears on a mosaic from Pompeii, represents the human soul leaving the body at death.

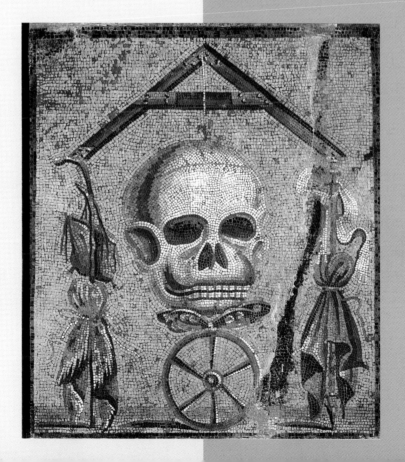

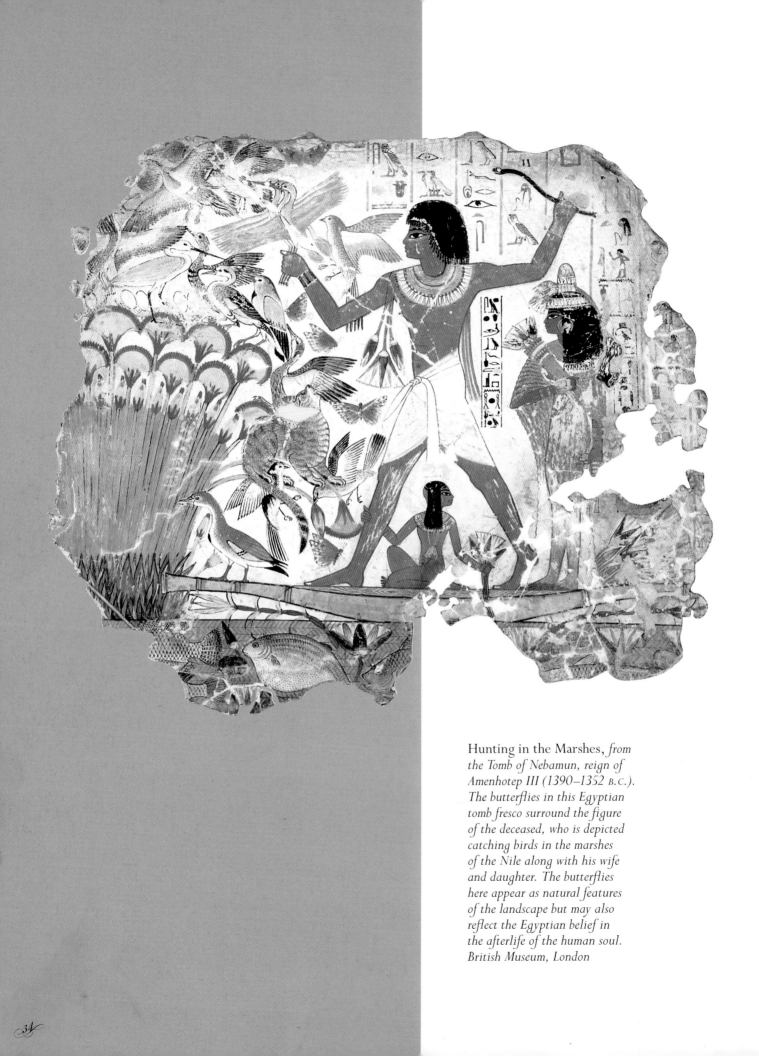

Hunting in the Marshes, *from the Tomb of Nebamun, reign of Amenhotep III (1390–1352 B.C.). The butterflies in this Egyptian tomb fresco surround the figure of the deceased, who is depicted catching birds in the marshes of the Nile along with his wife and daughter. The butterflies here appear as natural features of the landscape but may also reflect the Egyptian belief in the afterlife of the human soul. British Museum, London*

skull, which bears the attributes of both beggar and king. On the right are the knapsack and stick commonly carried by tramps and on the left a scepter with a white ribbon and a bit of purple cloth indicative of royalty; the mason's level indicates that the beggar's staff and the royal scepter are of equal value at the time of death, a sentiment expressed in the inscription, *Omnia Mors Aequat* (In death we are all equal). The butterfly emerging from the skull is clearly a representation of the soul leaving the body, an image that has survived into the modern era (see page 67). Butterflies also appear on many Greek and Roman coins and funerary monuments as symbols of the soul; in a carving on a Roman sarcophagus the goddess Minerva places a butterfly on a newly created human being.

The familiar story of Cupid and Psyche, whose origins undoubtedly lie somewhere in Greek mythology, is best known to us in the Latin version written in the second century A.D. by Lucius Apuleius in his book *Metamorphoses,* or *The Golden Ass.* A student of Greek philosophy, Apuleius appropriately gives the Greek name of Psyche to a beautiful Sicilian princess, who is transformed into an immortal soul after she marries Cupid, the god of love. Cupid's mother, Venus, the goddess of beauty, had been jealous of Psyche's beauty and instructed her son to cause the girl to fall in love with a monster. However, Cupid fell in love with Psyche himself, and Venus subsequently forced her to undertake many difficult tasks to punish her. Cupid's father, Jupiter, finally granted them permission to marry, and she earned her immortality as Cupid's wife.

Early Christians borrowed many classical images and symbols in depicting Christian themes, and the butterfly is among them. A Christian version of the story of Cupid and Psyche, complete with butterfly wings, can be found painted on walls of the Roman catacombs, which were first used as burial places and later as secret places for Christian worship. In the catacomb of Saints Peter and Marcellinus, for example, Cupid and Psyche are pictured ardently embracing, he with the wings of a dove and she with the wings of a butterfly. The butterfly can be also found in Renaissance images of the Christ Child, who holds the fragile winged creature in his hands as an emblem of the human soul for which he is responsible. Dutch and Flemish still lifes of the seventeenth century often include a butterfly along with other Christian symbols (the wine and bread as elements of the Eucharist; ivy as eternal life; fruits as symbols of the Virgin and Child; birds and butterflies as symbols of the human soul).

The butterfly-soul has taken many different forms over the centuries, not just in art and literature but also in superstitions that have become part of daily life in many cultures. In Andalusian Spain there is a custom that an heir must throw unmixed wine over the ashes of the deceased as a toast to the butterfly that will escape with the soul; *Volitet meus ebrius papilio* (My butterfly flies inebriated) is a common epitaph in this region. In parts of southern Germany, butterflies are thought to be the souls of children. Similarly, an Irish law of 1680 decreed that a white butterfly could not be killed because it was the soul of a child. Furthermore, if a white butterfly were to fly in circles around a woman, it indicated she was a witch who probably killed that child and she, in turn, had to be killed. In Wales, there are some who believe that after death, the soul escapes the body in the form of a white butterfly. A poem in a Welsh cemetery in memory of a son reads:

When loved ones are laid to rest
Where the wind ruffles the wild grass
Butterflies streak the air like white lightning.

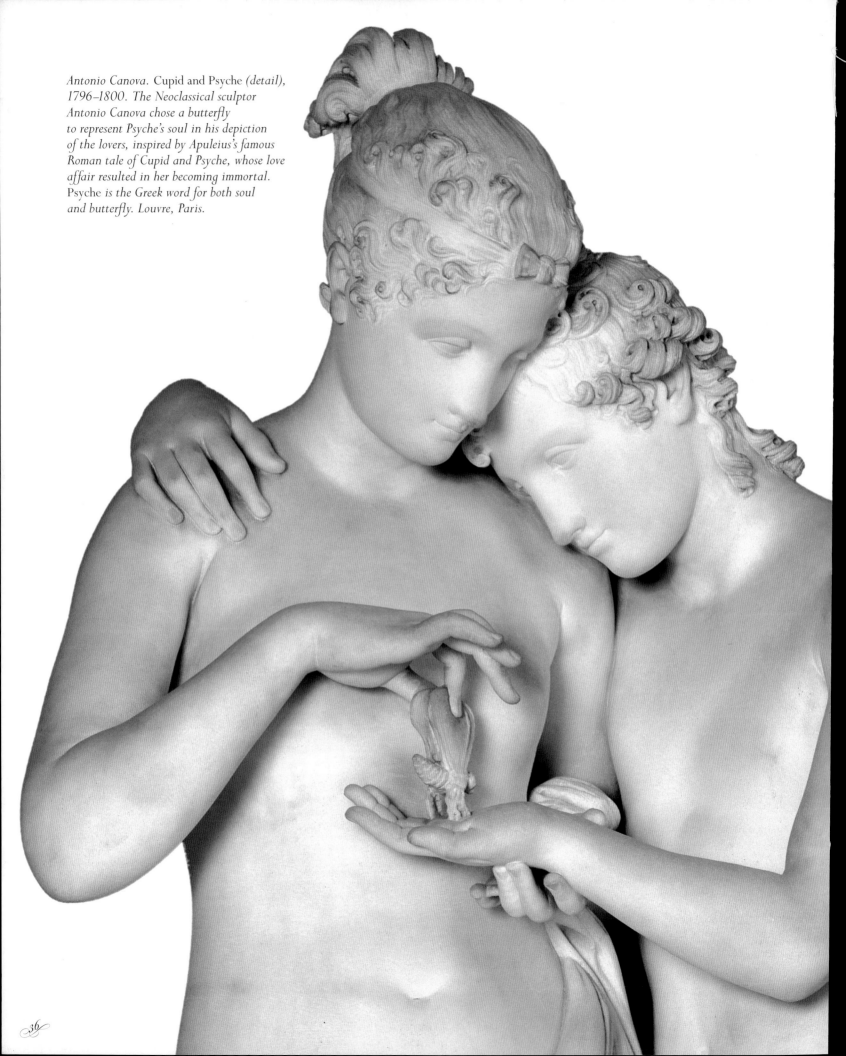

Antonio Canova. Cupid and Psyche *(detail), 1796–1800. The Neoclassical sculptor Antonio Canova chose a butterfly to represent Psyche's soul in his depiction of the lovers, inspired by Apuleius's famous Roman tale of Cupid and Psyche, whose love affair resulted in her becoming immortal.* Psyche *is the Greek word for both soul and butterfly. Louvre, Paris.*

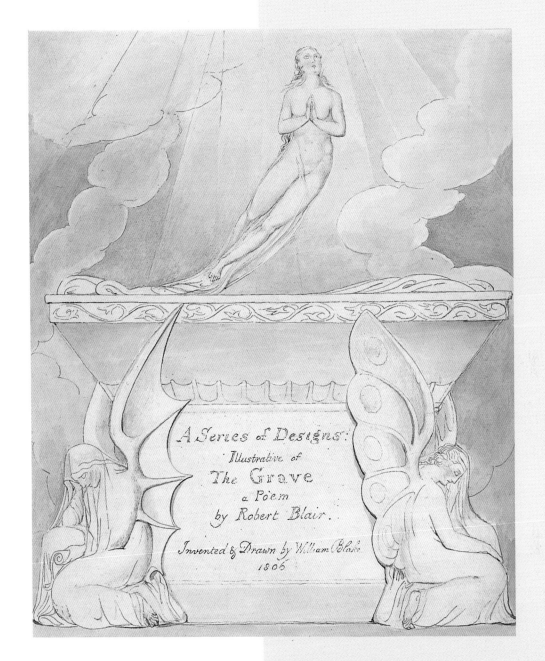

A Series of Designs:
Illustrative of
The Grave
a Poem
by Robert Blair.

Invented & Drawn by William Blake
1806

William Blake. Title page of The Grave by Robert Blair, 1806. The visionary English poet and artist William Blake was well aware of the significance of the butterfly as a symbol of the human soul. In this title-page illustration of Blair's poem he has depicted a tomb bordered with tendrils and lilies, which represent Christ's Resurrection. The veiled figure on the left with bowed head and bat wings indicates death and mourning; the scroll in her hand may be a list of the dead. The figure on the right with butterfly wings represents Psyche, symbol of the immortal soul. The Huntington Library, Art Collection, and Botanical Gardens, San Marino, California

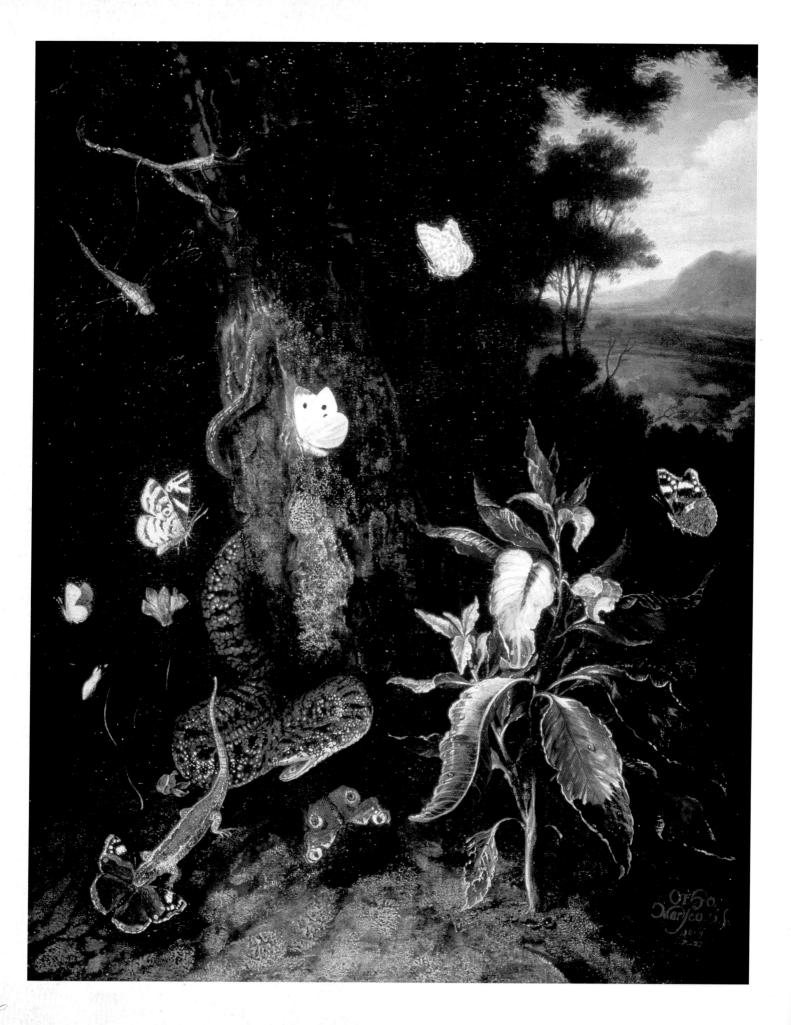

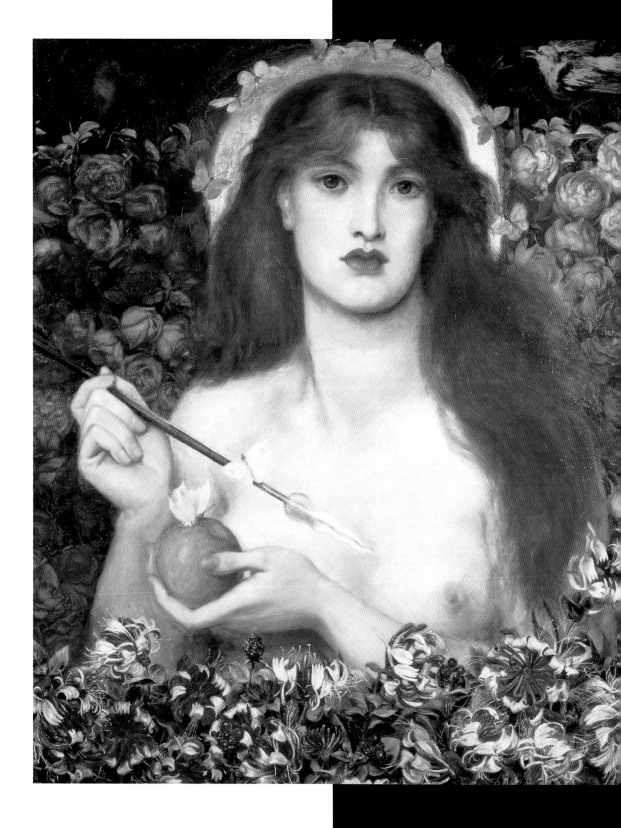

Dante Gabriel Rossetti. Venus Verticordia,
*1864–68. Rossetti, a leading British Pre-Raphaelite
painter and poet, has transformed his model,
Alexa Wilding, into the goddess of love and equipped
her with Cupid's arrow and the golden apple given
to Venus by Paris, whose love for Helen started
the Trojan War. The roses and the honeysuckle are
symbolic of love, and the butterflies represent the
souls of dead lovers. Russell Coates Gallery, London*

Myth

The theme of the butterfly as the soul is perfectly
exemplified in this fairy tale from Poland in which
the queen's guardian angel, who watches over her
in perilous times, has taken the form of a butterfly.

A long time ago, Premislaw, the king of Poland, married Rixa, the daughter of the king of Sweden, a few years after his first wife, the beautiful and beloved Luidgarda, had died, leaving him without an heir. Rixa soon presented him with a beautiful son; she knew nothing of the sad death of Luidgarda, as everything had been carefully concealed from her.

Rixa had a good and tender heart, and one day, when Anulka, her lady-in-waiting, suddenly fell ill, she took care of her. It was at this time, when Anulka was delirious, that Rixa learned of the existence of Luidgarda, although she did not know who she was. Curious, Rixa waited until Anulka recovered to ask about this mysterious Luidgarda.

"Luidgarda!" Anulka said. "From whom did you hear that name?"

"You mentioned it yourself during your illness, when you were delirious with fever. Tell me why you called her 'My lady,' and why you referred to her as the queen. And what did you mean when you spoke about death and drowning?"

"I don't know anything," said Anulka, frightened. "One is not responsible for what one says in a delirium. What you heard was merely incoherent babbling." But her face had become pale, and her hands were shaking. Rixa wasn't satisfied; she insisted on knowing the truth, but she couldn't get another word from Anulka.

"Perhaps you are afraid of King Premislaw?" asked Rixa. "I promise you I won't tell him a word about this."

At last the woman was about to speak, when through the open window, riding a gentle breeze, a beautiful butterfly flew in and sat on Anulka's shoulder. Rixa was about to brush it off, but Anulka protected it with her hand and carried the butterfly to the flowers in the window box.

"Luidgarda's soul has come to implore me to keep her secret. Perhaps she doesn't want us to remember that wretched event; therefore, I will not speak."

Rixa was mesmerized by the strange, multicolored butterfly. Anulka told her that the butterfly had the same colors as Luidgarda herself: golden hair, white hands, light blue eyes, and a dark blue dress. She suggested that the butterfly might become Rixa's friend. "Although the butterfly cannot speak, she hears and understands everything. Let her know about your wishes; tell her your sorrows and your hopes. She will hear and protect you in some way."

From that moment on, the butterfly came almost every day to sit on the flowers at the windowsill, as Rixa waited impatiently to share what was in her lonely heart. Since Poland was in the midst of chaotic civil wars, King Premislaw was far away, so Rixa spent the silent hours watching over her baby's cradle and talking to the butterfly.

One day her sister-in-law told her of a dream about a black horse, which was a bad omen. That same evening when the butterfly came in, it flew three times around Rixa's head and then went away without sitting on the flowers. Taking this as a sign, Rixa and Anulka decided that it would be best if Rixa not sleep in her own bed that night. Rixa sat with her son in Anulka's room all through that endless night, while the sister-in-law watched at the window and Anulka guarded the door. A foggy, gloomy dawn finally arrived, creeping in slowly and reluctantly. When Rixa returned to her room, accompanied by her entourage, they were shocked to find an ax stuck in the mattress where her head would have been. A strong arm had thrown that Caucasian mountaineer's ax with the intent to kill, but the butterfly had warned them.

A few months went by, Rixa's sister-in-law once again came to her with a bad omen, this time a dream of a black swan. The butterfly appeared a few moments later, flying around the little prince's cradle three times before disappearing through the window. Considering the danger, Rixa and Anulka decided to do the same as before. Again it seemed as if the night would never end. When the gloomy day dawned, everyone gasped in horror as they entered the queen's bedroom. The little mattress in the baby's cradle was pierced by an arrow belonging to the Tartars. Rixa wept for days, yearning for her husband's return.

Some weeks later, her sister-in-law came to Rixa with another dream, this time of a big, white eagle flying in the red sky with its wings spread. At last, this was an omen of happiness. At that moment, the butterfly flew in, alighting momentarily on a bright blade, then fluttering over to the flowers at the windowsill.

A messenger on horseback had brought the happy news that Premislaw was coming home. The gloom that had hung over the castle like a mist lifted; everyone started cleaning, polishing, and preparing a feast for the king's arrival. Anulka admonished Rixa to be thankful to the golden-winged butterfly, which was none other than Luidgarda's spirit that had protected her during the king's absence. Anulka made her promise to take the king to the place where Luidgarda met her death and to take a bunch of roses. She then led Rixa through an underground passage that opened into a cave with a pond of clear water at the center. Rixa looked into the water and her eyes filled with tears.

After days of celebrating, Rixa picked a bunch of red roses one day while walking with the king, and a thorn pricked one of her fingers. The king wanted to bandage her wound, but Rixa said: "I know of some water that will heal it. Please come with me."

Quickly and silently they walked to the underground passage. When they reached the pond in the center of the cave, Rixa gave the king the bunch of roses and said: "Please cast these flowers here, where Luidgarda died. She came back in the shape of a butterfly to save my life and our son's."

Without hesitating, the king dropped the roses one by one into the deep, clear water. As Rixa watched them drop, her crown fell at her feet. A butterfly alighted on the pearls of the crown as the king picked it up. They waited for the butterfly to take flight, but it did not; instead, it turned into solid gold, and the white and blue of its wings changed into diamonds and turquoises. The king placed the crown on Rixa's head, and she always wore it with great love in her heart.

When she died, the crown passed into the king's treasury. A hundred years later, when Edvige, daughter of the king of Hungary, became queen of Poland, she, too, wore it on her golden head.

Not all butterfly souls have a benign aspect. In many parts of Europe, including Scotland, Germany, and the Baltic countries, butterflies and moths are regarded as the souls of witches and various superstitions still exist regarding the way in which butterflies should be treated. In parts of both Brittany and Lithuania, for example, a butterfly is considered a witch or a goddess of death. Serbians and Westphalians also traditionally believed that butterflies embodied the souls of witches, and a Serbian proverb says that if you kill a butterfly, you kill a witch. If one can find a witch asleep and turn her around without waking her, the soul will not be able to reenter her body through her mouth, and, separated from her soul, she will die. On February 22 in Westphalia, St. Peter's Day is the time to expel all witches. The children are sent to houses around town with hammers to knock on doors and chant rhymes and incantations that will rid the town of witches.

In Spreewald, Germany, if a night butterfly strays into a room, it is believed it is a witch and must be killed immediately. In different parts of England, certain butterflies must be killed to suppress bad spirits: white moths in Somerset, red butterflies in the north, the first butterfly of the spring in Dorset. These beliefs have led to other roles for the butterfly as an omen of good or bad luck. For example, in Bulgaria, a dark butterfly means sickness, whereas in England white butterflies may presage a rainy summer and black ones a series of thunderstorms. For the ancient Romans, however, a butterfly in the house was a good omen and heralded the coming of spring.

Butterflies and Weather

Some people believe that if a tiger moth caterpillar's red bands are narrower than usual, there will be a severe winter ahead, both in intensity and duration. A milder winter is indicated by the caterpillar's wider red band. And others believe that when a butterfly flies into your face, cold weather is coming soon. And others say that if the butterfly is yellow, there will soon be a frost that will turn the leaves into the same color as the butterfly. The Zuni Indians believe that when a white butterfly flies from the southwest, one should expect rain, and if the first butterfly of the summer season is white, it will be a rainy season. However, if the first butterfly of summer is dark, it will be a season of thunderstorms.

The Aztecs believed that the happy dead—that is, the warriors and sacrificed individuals—returned to earth in the form of butterflies to assure their relatives that all was well. These butterflies would fly around the house and light upon bouquets of flowers, which were carried by Aztec men of high social rank. It was considered ill mannered to smell a bouquet of flowers from the top, which was reserved as a spot for the departed souls to visit. Mayans from the Yucatan region of Mexico also believed that their dead warriors would come to visit earth disguised as butterflies. The Day of the Dead is a festival that has been celebrated in Mexico from pre-Aztec times, and although many of the decorations seem to be gruesome emblems of death, the festival is actually a celebration of life. Also known as the Day of the Souls Returning, this yearly ritual takes place in virtually every Mexican village and city around November 1, All Souls' (or Saints') Day in the Christian world. Maria Sabina, a Mexican healer and visionary, pointed out to me that the Day of the Dead, when the butterflies representing certain old souls would return home, coincides every year with the spectacular migration of the monarchs from the north to their breeding ground high in the Sierra Madre. It is as if they have returned to an ancient spiritual place of power, a place of high magnetic energy in the center of a neo-volcanic zone. Within this natural temple of butterflies in the mountains is a sacred stand of sixty-foot-high

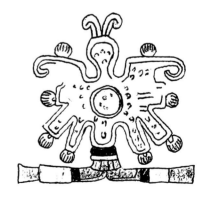

This Mexican butterfly in its role as a symbol of the soul appears in the 15th-century Borgia Codex.

oyamel trees that becomes completely covered with monarchs, as many as 10,000 in each tree. *Abries religiosas* is the Latin name for this type of fir tree, perhaps because its boughs were used in Precolumbian religious ceremonies and because oyamel forests are like natural cathedrals.

A traditional Japanese belief is that people have the ability to deposit their souls with animals, making them invulnerable to death. A white butterfly may be the soul of a living person. If it enters a house, it should be treated gently and kindly and not molested, because it could be a loved one or a friend with a message. He or she may be dying, for instance, and the white butterfly is the soul about to pass into another world. These haikus represent that sentiment:

Over the Dianthus. See. A white butterfly, whose soul I wonder.

—Kokku

Butterfly in my hand, as if it were a spirit, unearthly, insubstantial.

—Buson

The flying butterfly, I feel myself a creature of dust.

—Issa

A Myth

A long time ago, an old man named Takahama lived in a little cottage behind the cemetery of the temple of Sozanji. Everyone in the village liked this gentle, quiet man but thought him strange, since he had never married nor had he any desire for the companionship of women. When Takahama became seriously ill, his sister-in-law and her son arrived to take care of him and bring him comfort during his last days. When he was near death, sleeping quietly in his bed, a white butterfly flew into his room and alighted upon his pillow. His nephew drove it out, fearing it would disturb the old man, but it returned three times, until all the doors and windows were barred and it could not enter. The nephew chased the butterfly through the garden, beyond the gate, and into the cemetery, where it hovered above a woman's grave for some time before disappearing. The name Akiko was inscribed on the headstone along with a description of how she had died at the age of eighteen. The gravestone was at least fifty years old and covered with moss; yet there were fresh flowers and a recently filled little water bowl. When the young nephew returned, he found that Takahama had just died. He shared the tale of his butterfly adventure with his mother, who told him that his uncle had been betrothed to Akiko, who had died the day before their wedding was to have taken place. Takahama had vowed to remain faithful to her, and he did so all through his life, visiting her grave daily, winter or summer, bringing flowers, sweeping it, and praying for her peace and happiness. When Takahama was dying and could no longer visit her grave, the white butterfly, the sweet and loving soul of the young Akiko, went to visit him.

In Assam, the Naga believe that their dead go through various transformations and are reborn at last as butterflies; if a butterfly dies, the soul is lost forever. A ritual in Myanmar (Burma) holds that rice has a butterfly soul and must be laid out in a trail from the field to the granary so that the soul may find the grain in order to produce a crop the following year. This may be related to a traditional Javanese legend from the region of Prajangan that butterflies migrate when the king of the butterflies summons all of his subjects to furnish him with information about the rice crop. The migration of large sulphur butterflies in Malaysia is said to be a pilgrimage to Mecca, and in Sumatra, a species of migrant butterfly is called *hadjis,* which means Muslim pilgrim. In 1883, the people of Java interpreted a migration of butterflies as a journey of the souls of 30,000 people killed by the gigantic explosion of Krakatau four months earlier. Natives of Sri Lanka (Ceylon) have long believed that the yellow migratory butterflies travel to a mountain called Sama-nolakande, or Hill of the Butterflies, and return white in color, their souls purged of taint.

The butterfly is believed by several peoples of the Pacific Islands to be a representation of the human soul. The Maori of New Zealand believe that the soul returns to earth after death in the form of a butterfly. In the Solomon Islands, it is said that dying men can choose what they will become at death and often select the butterfly. In Samoa, it is believed if a butterfly is caught, the taking of its freedom would cause its spirit to instantly kill the captor. If you try to capture freedom, it will surely elude you, if not destroy you.

According to an Australian Aboriginal myth, when death first occurred in the world, it was assumed that the dead had been taken into the spirit world to come back in another form. The caterpillar volunteered first to go up to the sky in winter to find out what had happened. On the first warm day, the dragonflies reported that the caterpillars were coming back in new bodies—multicolored butterflies.

Another Aboriginal story of transformation, which has been passed down through the generations, tells of a man and his son who were walking through the outback when the boy suddenly fell ill. The father had built a shelter to protect his son, and then he left to find food and medicinal plants, which took a few days. When the father finally returned, his son was gone. In despair, he leaned against a tree for support during his anguish, and through his tears he noticed a cocoon in its branches. He knew that the cocoon represented the shelter he had built for his son, and his tears stopped, for he realized then that the boy's spirit would soon be released as a butterfly.

OPPOSITE:
Jack Wunuwun. Bonpa *from the Butterfly Morning Star Song Cycle, 1990. Wunuwun, an Australian Aboriginal artist, was a leader of the Dhuwa Moiety, Ngal Clan, which is the keeper and custodian of the Morning Star ceremony that celebrates the cycles of nature through symbols of birth, death, and regeneration. This is part of his series of eucalyptus-bark paintings depicting different aspects of the Morning Star myth, using natural ochers, earth pigments, and an iridescent purple/brown pigment called* raitpa. *At the artist's funeral in 1990, an unusually large brown butterfly,* Bonpa, *circled overhead, and those who were present are certain that it was the artist's soul.*

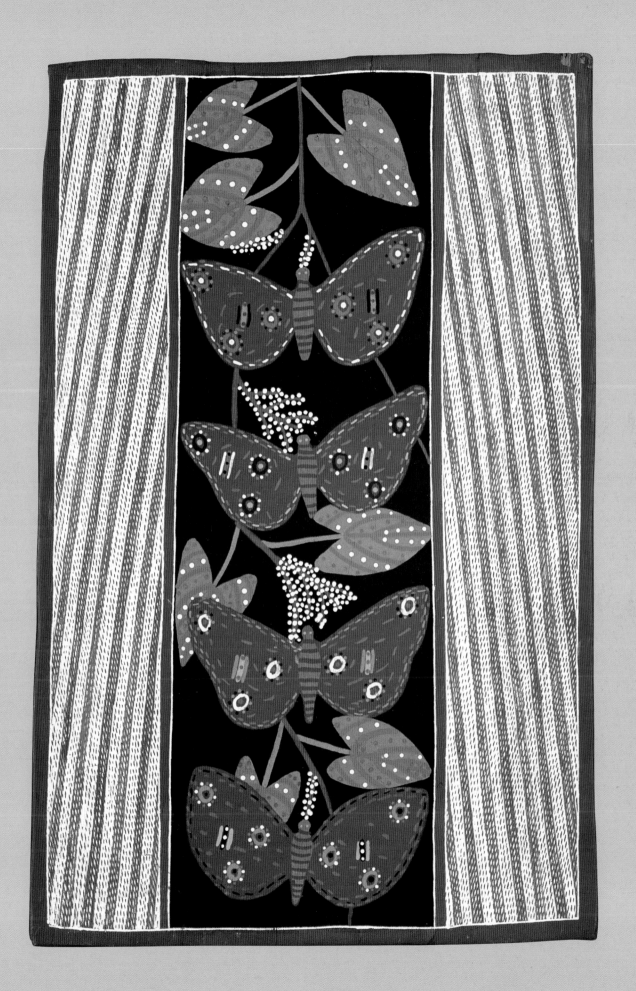

Fairies and Other Magic Butterflies

The English word *butterfly* derives from the Old English *buterfloege*, presumably because of a widespread belief in the Middle Ages that butterflies were really disguised fairies stealing butter (Germans also believed that butterflies stole butter, along with milk and cream). Fairies appear in the folklore of many cultures and in many different disguises, as elves, leprechauns, genies, nymphs, and other supernatural creatures that can be both good or mischievous, if not downright sinister. Our traditional image of fairies as tiny, delicate, winged creatures evolved during the nineteenth century in Victorian England, but originally they were not so appealing. Oddly, for a creature wearing butterfly wings, fairies have no souls and at death simply disappear. They were said to carry off adults and children, leaving changelings in their place, to a limbolike fairyland, from which people could not return if they ate or drank there. Humans can marry fairies but with rigid rules that if broken may result in death (a piece of fairy lore similar to the stories of Cupid and Psyche, page 35, and Tolowim Woman page 62), and some fairies are deadly to human lovers. As we know from countless fairy tales, fairies may tell fortunes, prophesying births as well as deaths.

In some cultures the butterfly is thought to be a divine messenger, like an angel (which accounts for angels with butterfly instead of bird wings in many medieval manuscripts). Albrecht Dürer, the northern Renaissance master, used the butterfly as a symbol of the spiritual ascent to heaven, more often in association with the Virgin Mary than with Christ. In several of his paintings and prints of the Virgin and Child, a butterfly alights near her robe, carrying the message of freedom from the grief that she will eventually suffer at the death of her Son.

Albrecht Dürer, Holy Family with the Butterfly, *1497. Fine Arts Museums of San Francisco, Achenbach Foundation for Graphic Arts, Gift of Elise E. Haas*

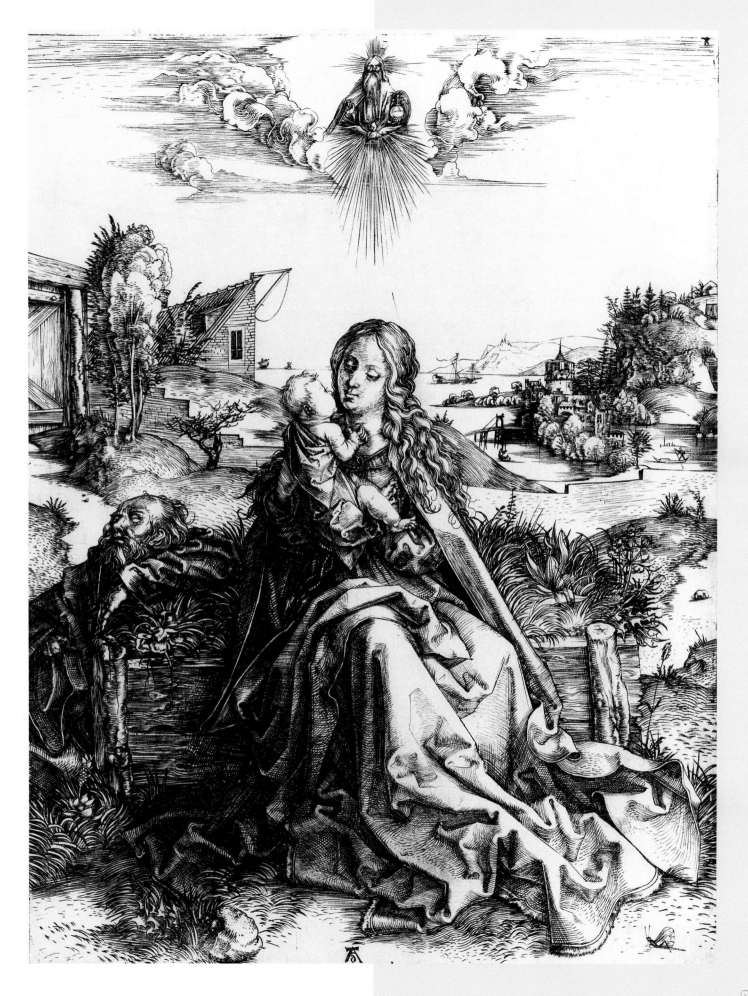

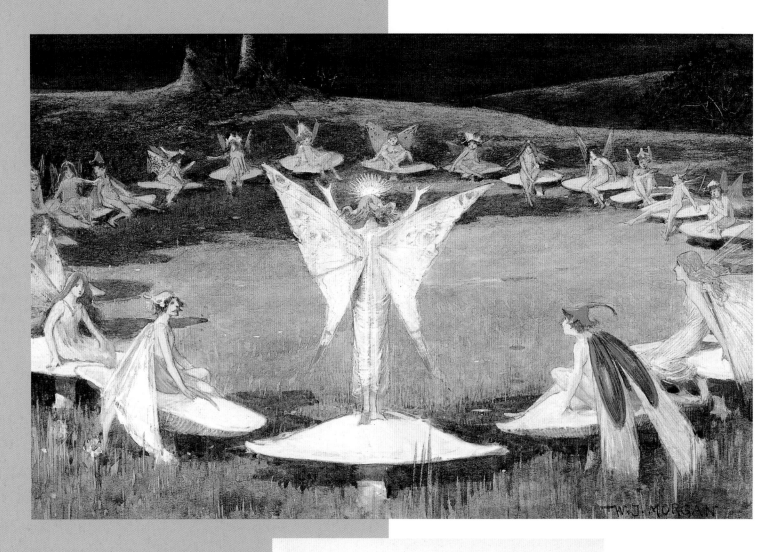

Walter Jenks Morgan. A Fairy Ring, 1900.
Fairies with butterfly wings were a favorite
subject for this turn-of-the-20th-century
British painter and illustrator of books and
magazines, including The Illustrated London
News. Leicester Galleries, London

Daphne Constance Allen.
Love in a Mist with Fairy
Flowers, c. 1900.
Obviously inspired by
the butterfly-and-flower
paintings of 19th-century
naturalists, this British
painter has added her
own touch of fantasy with
a flight of naturalistically
depicted fairies. Leicester
Galleries, London

OPPOSITE:
John Simmons, Titania,
Queen of the Fairies,
1866. In depicting
this scene from
Shakespeare's
Midsummer Night's
Dream (Act III,
Scene I), the English
painter chose to give
Titania the wings
of a butterfly. The
flower featured in this
painting is woodbine,
which has narcotic
properties and is
associated with night
and with death.
City of Bristol Museum

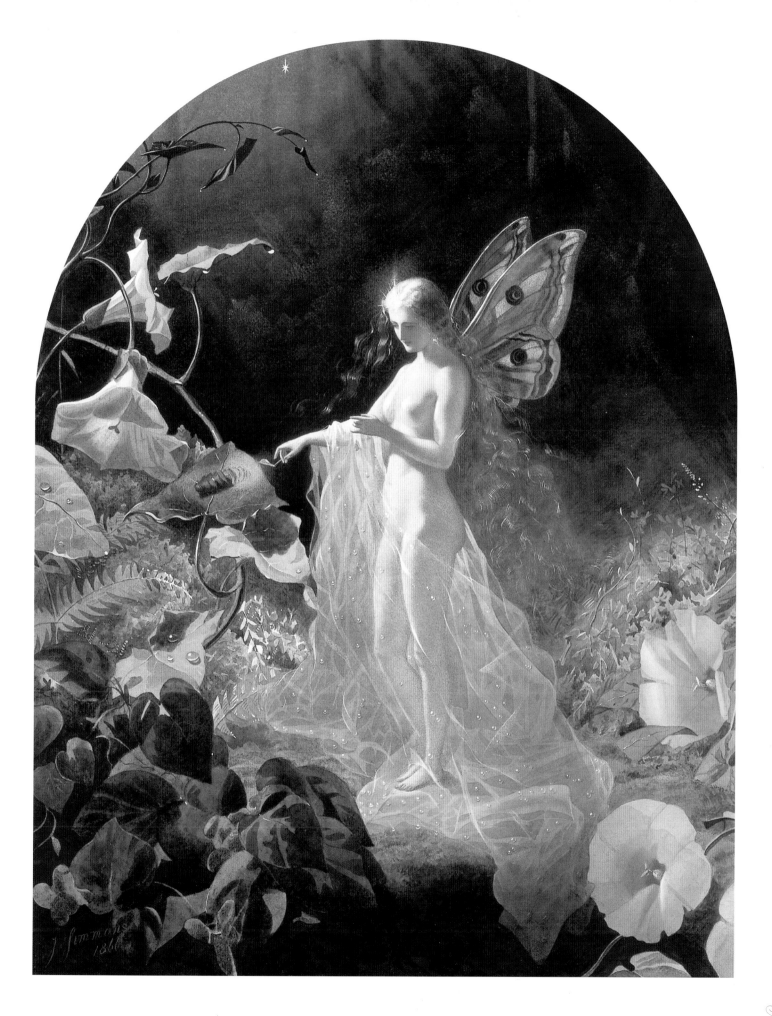

A Native American butterfly legend also has the butterfly playing the role of messenger, especially in making wishes come true. First, one must capture a butterfly and whisper a wish to it. Since butterflies are not capable of speaking, they cannot divulge that wish to anyone but the Great Spirit. Therefore, when one releases the butterfly, it will journey to the heavens to deliver its message and the wish will be granted. The Blackfoot Indians believe that dreams are brought to us in sleep by butterflies. When a butterfly is painted on a Blackfoot lodge, it means that the image came to the dweller in a dream or through some form of divine inspiration. When a cross is painted on a lodge, it means that whatever the design, it was brought to the painter in a dream by a butterfly. Blackfoot women embroider the sign of a butterfly in beads or quills on a small piece of buckskin and tie this in their babies' hair when they want the children to go to sleep. Also there is a lullaby the mother sings in which the butterfly is asked to come and put the child to sleep. The Delaware Indians traditionally embroider a beaded butterfly on a small deerskin pouch, into which the umbilical cord is placed before the pouch is tied around the baby's neck.

In contemporary Mexican mythology, Carlos Castaneda, in his book *Tales of Power*, describes the moth as a sorcerer's apprentice and the guardian of eternity. Moths are a repository of knowledge, which Castaneda's sorcerer says is revealed by the powder on their wings, a dark gold dust, the dust of knowledge. "Knowledge comes floating like specks of gold dust, the same dust that covers the wings of moths." Navajo men and boys, before running a race, catch a butterfly, and without hurting it, rub some of the colored "dust" from its wings onto their legs, so they may be swift and light and run with the spirit of the butterfly.

Because butterflies so often carry magical powers, many different cultures have developed rules regarding their treatment, some of them involving superstitions, some of them sacred rituals integral to religious beliefs. The capturing and killing of butterflies—considered nowadays either a scientific pursuit or a traditional (if no longer fashionable) summertime activity—has a long and varied history in different parts of the world. For some Europeans, the

Victorine Buttberg. Fairy Thread from The Spider's Web & A Fairy Chase, c. 1900. *This British artist clearly owes much to the fashionable butterfly designs of such fin-de-siècle artists as Aubrey Beardsley and Kolomann Moser.*

capture of a butterfly brings luck, especially if the butterfly is the first of the season or is white in color, although in Devon, England, such a butterfly should be killed. A Scottish tradition holds that it is unlucky to kill or keep a butterfly, whereas in other cultures it is unlucky not to do so.

The magic of the butterfly has led in many areas to its becoming a source of medicinal strength. The San (Bushmen) of Botswana dry the roots of the local milkweed on which the African monarch, *Danaus chrysippus*, feeds. They crush the roots into a fine powder and use it like snuff for various remedies, such as for headaches. Another powerful medicine is produced when the single quill of a pheasant is added to a clay pot with three butterflies and burned. Three incisions are made on the forehead of a patient and the mixture applied in order to protect against bad luck and evil forces.

Traditional healers in Nigeria use the butterflies *Papilio demoleus* and *Colotis danae* for various medicinal purposes. In one case, seven butterflies are burned in a clay pot and mixed with a local soap until it is a uniform consistency. In order for a bachelor to find a wife, he must bathe with this soap regularly. Healers in Ilorin claim that the same mixture can be used to decorate or paint the eyelashes in order to achieve the same result.

Australian Aborigines use insects extensively as medicine and food. During winter months, many people in New South Wales collect, roast, and eat the Bogong moth, which can be found in profusion in the rock crevices of caves on Mount Bogong. The moths are cooked in the sand, and hot ashes are used to burn off the wings and legs; after the heads are removed, the crisp moths are eaten or ground into paste for bread or cakes. Aborigines also use the silk bag made by the larvae of the processionary caterpillar as a protective dressing for wounds.

Family crests, a tradition in Japan since the 11th century, have been used to decorate formal costumes and to identify warriors on the battlefield. Many different designs were used for these crests, including the butterfly, a favorite Japanese motif.

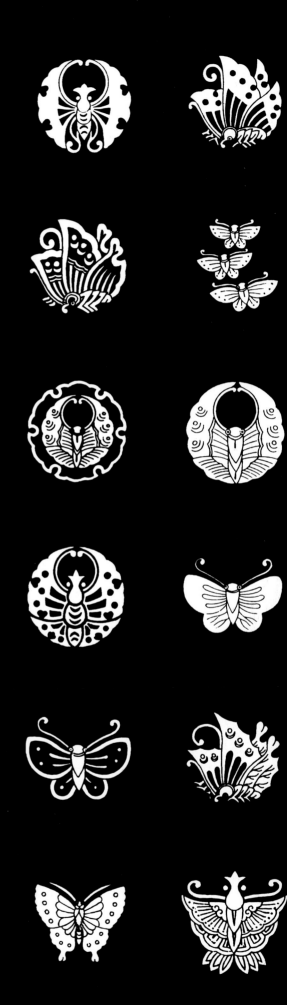

The Butterfly Dance and Cocoon Magic

Perhaps the most impressive, and certainly the most beautiful, sacred butterfly ritual is the butterfly dance, which can be found in several different cultures and can take many different forms. In some parts of West Africa, including Burkina Faso, the Bwa (Bobo Ule) and the Nuna peoples have mask societies. Masks are essentially receptacles of spirits and play an essential part in ceremonies connected with the dead and with the soul. The only insect in the pantheon of animal masks is the butterfly, and its design, though not entirely unique, is very rare. The central place is for the face of the wearer, with wings, like arrows extending out from each side. The wing patterns are bold with concentric circles or triangular designs. The masks are attached to a fiber costume that covers the head as the wearer bites hard on a thick fiber rope.

These butterfly masks are worn at mask festivals, at the celebration of the vernal equinox, and at funerals of members of the mask society. It is said that butterfly energy is the fertilizing force that helps the crops renew and grow strong. The Bwa people believe that the spirits of their ancestors can find peace in animal bodies, and when a masked dancer performs in a ceremony, he or she manifests the power and spirit of that particular animal or animals. The butterfly signifies the soul released from an earthly existence to fly to the world of spirit.

More unusual is a butterfly mask with birds and chameleons perched on the wings, affixed with iron pins. Animals and birds are admired and respected as embodying different aspects and qualities of life. Birds are messengers between humankind and the supernatural world, as well as symbolizing freedom. The chameleon represents illusion and camouflage. And the butterfly is the spirit, now free to join its ancestors.

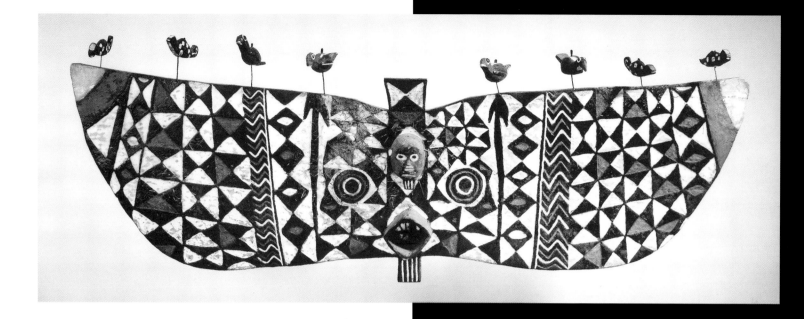

This butterfly mask was made by the Bwa people of Burkina Faso in West Africa for use in sacred ceremonies. The Walt Disney-Tishman African Art Collection

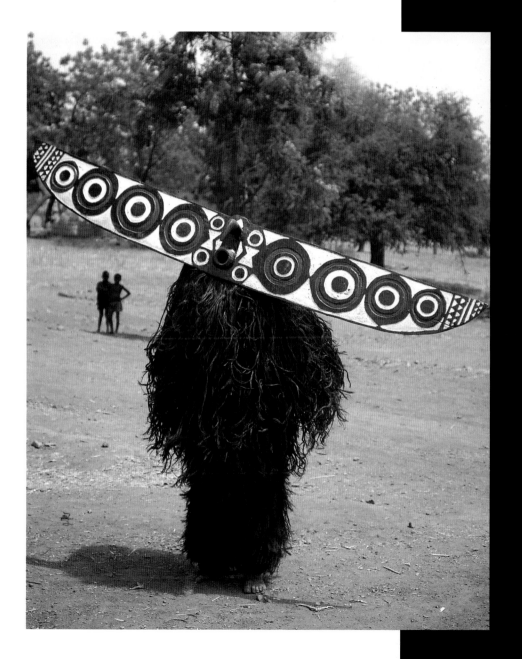

This butterfly mask is worn by a Bobo dancer in Burkina Faso.

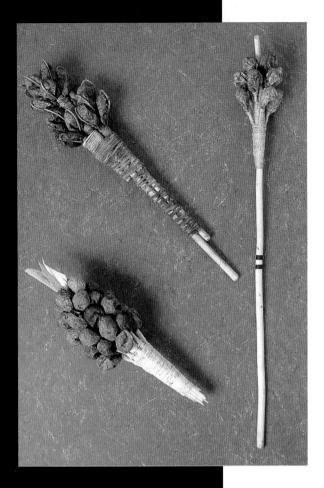

Ankle rattles made from cocoons of Rothschildia cincta from the Tarahumara tribe of Chihuahua, Mexico from northwest Mexico. Denver Museum of Natural History

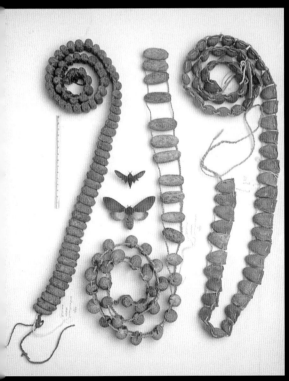

These ankle bracelets of the San (Bushman) people of Botswana in southern Africa are made of cocoons from various species of moths. Denver Museum of Natural History

Cocoons of various species of moths in Saturniidae and other families have been made into rattles, ankle and leg bracelets, purses, or other artifacts in different cultures around the world since ancient times. At present, the tradition is still alive in certain parts of Africa and Mexico. The cocoons are cut and filled with various materials, such as pieces of broken seashells, small pebbles, seeds, beans, or chips of ostrich eggshell, and then sewn together with sinew or hemp fiber and bound to various woods, fabric, or fur and feathers. Cocoon rattles are traditionally considered very powerful and are used in various ceremonies by shamans and medicine men.

Among many cultures in southern Africa, including the Zulu, Sotho, Swazi, and Vendu (all Bantu-speaking) and the San, the use of moth cocoons is an important part of healing trance ceremonies. The Zulus fill cocoons with small stones and sew them to goat skin to use as rattles, while the Swazis use various groupings of cocoons in repeating numerical patterns. A San tradition is to slit cocoons down the side, eat the larvae, fill the cocoons with fragments of ostrich eggshells, and wear them in dances.

The Seri people of Sonora, Mexico, used cocoon rattles in a white-tail dance, and the Yuki of northern and central California would use them to accompany a singer in the ghost initiation ceremony, as well as eat the pupae from the cocoons they collected. Snake shamans from the Yukot tribe used the rattles in ceremonies to prevent snakebite, while the Miwoks may have used the rattles as hair ornaments and handheld rattles. The Sierra Miwok shamans considered the cocoon objects to be too sacred and powerful for other members of the tribe to handle, whereas the Coahuiltec people of Monterrey wore cocoon necklaces to prevent the growth of facial hair. Pomo shamans considered the cocoon rattles a vital part of their medicine bag and also used them in a ritual dance. The Papago found the cocoons on desert bushes, filled them with fine gravel, strung them on buckskin thongs, and wore them for special ceremonies. Maidu shamans of central California used cocoon rattles wound around the leg or arm in ceremonies while praying to the spirits, and sometimes as a cure or a poison. All of these cocoons produced sounds, which helped induce a transformational state and enhanced

the rhythms of running and dancing. The Maidu also created an offering flag composed of acorns, cocoons, and feathers of the northern flicker.

The sacred dancers of the Tarahumara people in Chihuahua, Mexico, wear the cocoons around their ankles or wrists in ceremonies. Like the ancient Greeks, they consider butterflies and moths to be reincarnations of the soul and a potent symbol of birth and death. The cocoon rattles are made into necklaces along with castor beans, mescal beans, and Job's tears, and other seeds, which are worn for medicinal and ceremonial purposes. The Tarahumara also eat butterfly larvae.

Over the past hundred years, after Native American tribes were divided into separate reservations, intertribal gatherings, known as powwows, were established and held on a regular basis. Many competitions take place at these gatherings, among them dance contests, and the butterfly dance is the most popular. There are many versions based on various legends, but the most powerful description I have yet encountered is that of Clarissa Pinkola Estes, who witnessed a sacred butterfly dance in Puye, New Mexico.

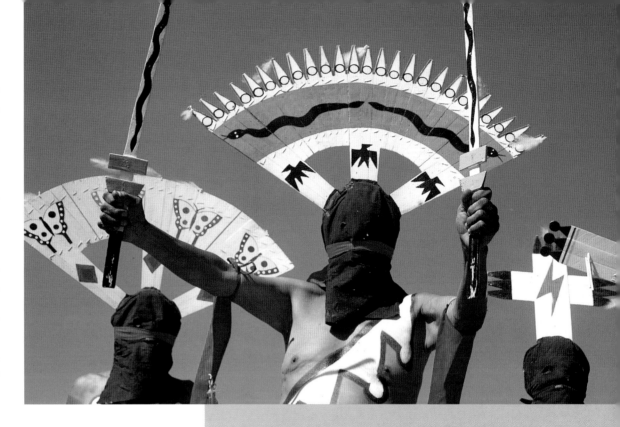

The Apache dancer wearing his butterfly headdress joins the dancer who personifies the snake.

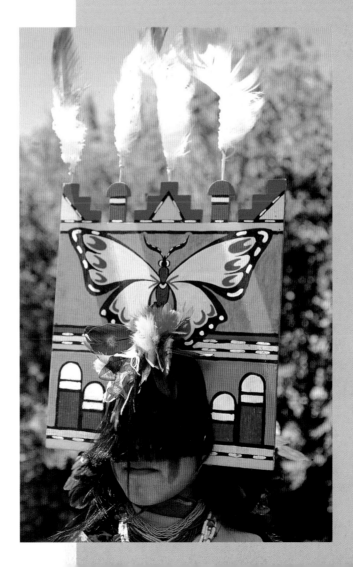

Tablita, a Zuni butterfly dancer

Myth

La Mariposa, Butterfly Woman

To tell you about the power of the body in another way, I have to tell you a story, a true story. For years tourists have come to Puye, a big dusty mesa in the middle of "nowhere" New Mexico. Here the Anasazi, the ancient ones, once called to each other across the mesas. A prehistoric sea, it is said, carved the thousands of grinning, leering, and moaning mouths and eyes into the rock walls there.

The Navajo, Jicarilla, Apache, Southern Ute, Hopi, Zuni, Santa Clara, Santa Domingo, Laguna, Picuris, Tesuque, all these desert tribes come together here. It is here that they dance themselves back into lodgepole pine trees, back into deer, back into eagles and Katchinas, powerful spirits.

And here too come visitors, some of whom are very starved of their geno-myths, detached from the spiritual placenta. They have forgotten their ancient gods as well. They have come to watch the ones that have not forgotten.

Visitors come with all manner of expectations, from the sacred to the profane. They come to see something that not everyone will be able to see, one of the wildest of the wild, a living numen, *La Mariposa*, the Butterfly Woman.

The last event is the Butterfly Dance. Everyone anticipates with great delight this one-person dance. It is danced by a woman, and oh what a woman. As the sun begins to set, here comes an old man resplendent in forty pounds of formal-dress turquoise. With the loudspeakers squawking like a chicken espying a hawk, he whispers into the 1930's chrome microphone, "'n' our nex' dance is gonna be th' Butterfly Dance." He limps away on the cuffs of his jeans.

Unlike a ballet recital, where the act is announced, the curtains part, and the dancers wobble out, here at Puye, as at other tribal dances, the announcement of the dance may precede the dancer's appearance by anywhere from twenty minutes to forever.

Unexpectedly, then, for everyone is bored to scowls, the drummer's arms begin drumming the sacred butterfly rhythm, and the chanters begin to cry to the gods for all they are worth.

To the visitors, a butterfly is a delicate thing. So they are necessarily shaken when out hops Maria Lujan. And she is big, really big, like Venus of Willendorf, like the Mother of Days, like Diego Rivera's heroic-size women who built Mexico City with a single curl of their wrist.

And Maria Lujan, oh, she is old, very, very old, like a woman come back from dust, old like old river, old like old pines at timberline. One of her shoulders is bare. Her red-and-black *manta*, blanket dress, hops up and down with her inside it. Her heavy body and her very skinny legs made her look like a hopping spider wrapped in a tamale.

She hops on one foot, and then the other. She waves her feather fan to and fro. She is The Butterfly arrived to strengthen the weak. She is that which most think of as not strong: age, the butterfly, the feminine.

Butterfly Maiden's hair reaches to the ground. It is thick as ten maize sheaves and it is stone gray. And she wears butterfly wings—the kind you see on little children who are being angels in school plays. Her hips are like two bouncing bushel baskets and the fleshy shelf at the top of her buttocks is wide enough to ride two children.

She hops, hops, hops, not like a rabbit, but in footsteps that leave echoes.

"I am here, here, here . . .

"I am here, here, here . . .

"Awaken you, you, you!"

She sways her feather fan up and down, spreading the earth and the people of the earth with the pollinating spirit of the butterfly. Her shell bracelets rattle like snake, her bell garters tinkle like rain. Her shadow with its big belly and little legs dances from one side of the dance circle to the other. Her feet leave little puffs of dust behind. The tribes are reverent, involved. But some visitors look at each other and murmur "This is it? This is the Butterfly Maiden?" They are puzzled, some even disillusioned. They no longer seem to remember that the spirit world is a place where wolves are women, bears are husbands, and old women of lavish dimensions are butterflies.

Yes, it is fitting that Wild Woman/Butterfly Woman is old and substantial, for she carries the thunderworld in one breast, the underworld in the other. Her back is the curve of the planet Earth with all its crops and foods and animals. The back of her neck carries the sunrise and the sunset. Her left thigh holds all the lodgepoles, her right thigh all the she-wolves of the world. Her belly holds all the babies that will ever be born.

Butterfly Maiden is the female fertilizing force. Carrying the pollen from one place to another, she cross-fertilizes mind with night dreams, just as archetypes fertilize the mundane world. She is the center. She brings the opposites together by taking a little from here and putting it there. Transformation is no more complicated than that. This is what she teaches. This is how the butterfly does it. This is how the soul does it.

Butterfly Woman mends the erroneous idea that transformation is only for the tortured, the saintly, or only for the fabulously strong. The Self need not carry mountains to transform. A little is enough. A little goes a long way. A little changes much. The fertilizing force replaces the moving of mountains.

Butterfly Maiden pollinates the souls of the earth. It is easier than you think, she says. She is shaking her feather fan, and she's hopping, for she is spilling spiritual pollen all over the people who are there, Native American, little children, visitors, everyone. She is using her entire body as a blessing, her old, frail, big, short-legged, sort necked, spotted body. This is a woman connected to her wild nature, the translator of the instinctual, the fertilizing force, the mender, the rememberer of old ideas. She is *La Voz Mitologica*. She is Wild Woman personified.

The butterfly dance must be old because she represents the soul that is old. She is wide of thigh and broad of rump because she carries much. Her gray hair certifies that she need no longer observe taboos about touching others. She is allowed to touch everyone: boys, babies, men, women, girl children, the old, the ill and the dead. The Butterfly Woman can touch everyone. It is her privilege to touch all at last. This is her power. Hers is the body of La Mariposa, The Butterfly.

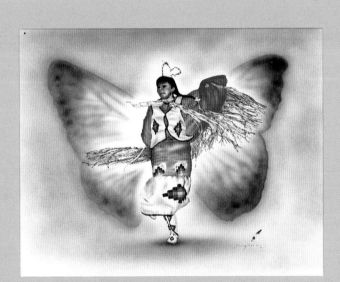

L. David Eveningthunder. On Butterfly Wings, *1997. This painting is based on the story of a beautiful butterfly who lost her mate in battle. Grief-stricken, she wrapped herself in her cocoon and started on a journey around the world. As she traveled, she stepped from stone to stone until she again found beauty; only then was she able to begin her life again. This figure is a composite of many butterfly dancers the artist, a member of the Shoshone/Bannock tribes, has seen over the years as he travels to powwows all over the country. Collection of the artist*

The Symbolic Butterfly

Happiness is a butterfly, which when pursued, is always just beyond your grasp, but which, if you will sit down quietly, may alight upon you.

—Nathaniel Hawthorne

In previous chapters we have seen the butterfly as a sacred symbol of goddesses and gods, of the human soul, the witch, and the fairy, but in this section we shall look at four other aspects of the butterfly that also exist in many different cultures: love, death, hope, and magic.

Love

One of the most pervasive aspects of the traditional butterfly image is that of love, both spiritual and sexual. Here are four very different interpretations of lepidopteran love:

↪ In early-seventeenth-century France, Saint Francis de Sales wrote that when night-flying moths see a flame, they are attracted to it and fly around it, seeking to know if the flame is as sweet as it is beautiful. They continue this until they burn themselves up, as do the young with the flames of desire.

↪ Along the Ivory Coast, young pubescent men hunt butterflies to gather the colors from their wings, which they then rub on their armpits and in the genital area in the belief that pubic hair will grow and it will make them strong and virile.

↪ In Romania, adolescent girls make a drink with the wings of butterflies so that they can attract suitable partners.

↪ A pair of butterflies symbolizes conjugal happiness in many Asian countries, and there are always butterflies in some form at weddings. Guests have butterflies of paper or silk as good luck blessings to bestow on the couple.

Kitagawa Utamaro. The Courtesan Yosooi Writing a Letter, *early 1800s. Art Institute of Chicago*

Myth

Zeus

turned his earthly lover, Io, into a milk-white cow so that his wife, Hera, would not discover her. Zeus would visit Io in a meadows filled with flowers and butterflies, but before long, Hera discovered Zeus's trickery and sent a stinging fly to poison Io and to pursue her through the valleys of the earth. Io was eventually driven to the shores of the distant Nile, and there among the reeds, broken and exhausted, she wept. A newly born peacock butterfly landed on her knee and remained there until the last of Io's tears were shed. The tears ran down over the butterfly's wings, and it is said that ever since the peacock butterflies have borne the tears of Io on the patterns of their forewings, a symbol of immortal pagan grief. The hind wings also drank in her melancholy, for in those blue mirrors, framed in the flecks of fiery brilliance, Io seemed to discern the image of the lost god himself.

Clothed in night, the mourning cloak butterfly, a relative of the peacock butterfly, enfolded Io in her compassionate wings to release her from the enchantment. In her cloak of sorrow, Io sought solace in the huts of the Egyptian shepherds, filled with dark longing for the god who neither betrayed his beloved nor forsook her. To this day the Nile still holds the peacock butterfly in its unrelenting shade.

Love is not only for the young, as this poem by Li T'ai-po describes a wife's longing for her husband, whose work has taken him far away.

> The eight months of the year!
> Butterflies are skimming in pairs over the
> Plants in the western garden . . .
> The scene tears at my heart.

In Japan butterflies are associated with young girls, since both are considered fair and fickle, frail and frivolous, lighthearted and given to dreaming, as well as beautiful, enticing, and charming. It is not unusual to say that a young girl in colorful attire resembles the wings of a butterfly or to use the metaphor of a butterfly gathering honey from many flowers in reference to a young beauty who flits from man to man. In this sense, a butterfly can also mean a false lover. Geishas in Japan are referred to as butterflies—vain women, concerned with self-adornment. Such women are frequently called *cho*, or *ko-cho*, from *cho,* the Japanese word for butterfly.

Madame Butterfly, a story written in 1900 by the American John Luther Long and transformed into a famous opera by the Italian composer Giacomo Puccini, tells the tragic story of a geisha, Cho Cho San, who attracts the attention and then the love of an American naval officer, Lieutenant B. F. Pinkerton. Although he is warned that their marriage will lead to tragedy, Pinkerton is determined to have her, saying "I must pursue her, though I damage her wings." In his play *M. Butterfly*, the Chinese American writer David Henry Hwang tells the story—which is also based on a true story—of a Frenchman who visits China, where he attends a performance of *Madame Butterfly*, whose star is actually a man masquerading as a woman. The Frenchman falls in love and begins an affair that lasts twenty years, during which time he never recognizes that she is a man, as well as a Communist spy. Although the butterfly in the title of the play is a direct reference to the title of Puccini's opera, the playwright was clearly aware of the butterfly as a symbol of both fickle love and transformation (see page 121).

Not all Japanese butterflies are unhappy in love. *Cho* can also mean good fortune, and crossing paths with a butterfly can bring good luck. Even today butterflies as a symbol of everlasting love are given to newlyweds as a blessing. Part of the Shinto marriage ceremony includes the sipping of wine three times with accompanying toasts: *O-cho* represents the masculine energy, *me-cho* represents the feminine, and the third toast signifies a happy union, the unity of opposites. *Nabi*, the Korean word for butterfly, also symbolizes love and warm-heartedness.

A Myth

A long, long time ago in China, a young man named Liang Shan-po attended a special school and met on the first day a new classmate whose name was Zhu Ying Tai. The two quickly became best friends, although Liang did not know that Zhu was a girl. Zhu had begged her parents to let her go to this school disguised as a boy, because girls weren't allowed to attend school at that time. As the school year progressed, Zhu fell deeply in love with Liang.

At the end of the school year, they went home together. On the way, Zhu hinted that she was a girl, but Liang didn't grasp her meaning. After she arrived home, she asked someone to tell Liang the truth, and he was so happy that he went directly to her home to make an offer of marriage, for he realized that he loved her more than his own life.

Zhu's father would not even consider accepting his offer and told Liang that he was too poor to marry his daughter. Besides, she was already betrothed. In exchange for allowing her to attend school, Zhu's father had compelled her to agree to marry a rich, older man. She begged her father to let her marry the man she loved, but he would not listen. Her heart belonged to Liang and to no one else, certainly not the man her father had chosen. She knew she would have to obey her father or else shame her whole family, and she did not want to do so. She was so desperate that she became ill. Day by day, she became weaker, until at last she died.

When the sad news reached him, Liang was deeply grieved. He wept in front of Zhu's grave, and the skies wept with him until their tears mingled with those on Liang's face. He was barely aware of the deep thunder and crackling lightning, but suddenly, in the midst of the storm, the grave split open. Without hesitating, Liang jumped into the grave, which closed at once.

The tears from the sky ceased, and a large, perfect rainbow appeared in the sky. Moments later, two beautiful butterflies flew out of the grave. They fluttered in the air among the flowers in perfect unison, like a pair of sweethearts, gazing into each other's eyes and hearts.

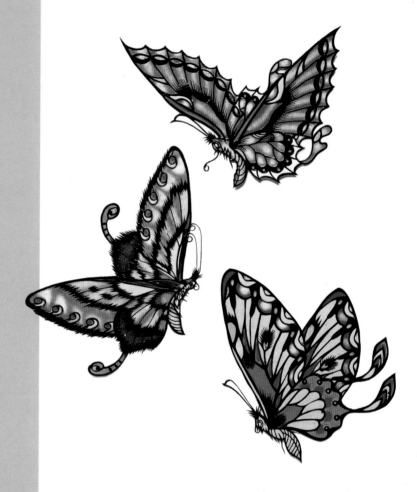

Papercut butterflies, China, 1980.
Victoria & Albert Museum, London

OPPOSITE:
Chinese Bridal Robe, 19th century.
The Newark Museum, New Jersey

Myth

*In America, butterfly love can take surprisingly different forms,
as in these two Native American stories, the first a Navajo myth
and the second a legend of the Maidu of central California:*

The Mothway Myth

There are many aspects to the butterfly spirit, some of which, taken to extremes, can cause great anguish. This story is about White Butterfly, a divine *berdache*, a bisexual god named Bergochidi, who represents the concerns of parents who face problems posed by children approaching a marriageable age. Bergochidi is aligned with the children as a guardian angel, but he is also known as a cosmic masturbator.

Among the ancient Butterfly People, Bergochidi would tickle the genitals of both male and female children to awaken their sexuality, a practice that would lead to incestuous behavior and early marriage. The Butterfly People ignored the traditional boundaries and went wild with *ajilee* or passion. They continued to indulge in incestuous relationships until they burned themselves up, not unlike a moth flying into flames. The Navajo thus believe that if a bit of the powder of a moth touches the skin or eye, it acts as an aphrodisiac and leads to incestuous dalliances and early marriages that end with the couples jumping into a fire. Moth powder is also an ingredient in love potions. This fable about out-of-control passion is used by the Navajo to explain the natural phenomenon of volcanoes, as well as to teach young people how to avoid incest, both in the family and in the clan.

Tolowim Woman and Butterfly Man

It was a beautiful spring. It was time for spearing salmon and hunting deer. Tolowim Woman was alone, restless and lonely. Her husband was away with the other men hunting and fishing, and this is a time when men must not be with their wives. Tolowim Woman was a good wife, but she, too, felt the spring, and she had grown weary of women's voices. Early one morning she put on her basket hat, left her house, and turned away from the river and the village and began a walk into the green hills. It was a lovely morning. By midday the sun was quite hot, and Tolowim Woman found some shade in which to rest under a manzanita bush.

She slept for a while, awakening to a gentle brushing on her cheek. Opening her eyes, she beheld the most beautiful butterfly she had ever seen. Laughing, Tolowim Woman tried to touch the butterfly when it landed on a branch above her, but it fluttered away. She took her seed basket hat and attempted to capture it, but again it fluttered just out

of reach. She decided that she must have this beautiful creature, and so she got up and began to follow the butterfly. All through the afternoon it led her on, deeper into the hills and away from her home. Soon her buckskin skirt was dim and torn, her basket hat lost, and her shell necklace broken and scattered, but she cared not and continued to follow the splendid butterfly.

As the sun sank low, the butterfly appeared to turn toward her. It settled on the earth at her feet. Suddenly in the dusky light Tolowim Woman saw a handsome, graceful man, naked save for the butterfly girdle around his slim waist. His hair was long and was held back in a red and black headband. Together they passed the night, and in the morning Butterfly Man said, "I am going to my home. Do you wish to come with me?" "Oh, yes," replied Tolowim Woman. Butterfly Man said: "It will take only one more day, but it is a dangerous and difficult journey, for we must cross the Valley of the Butterflies, and they will surely try to take you from me. Will you do as I say so that I may safely lead you through this danger?" Tolowim Woman promised to do as he told her.

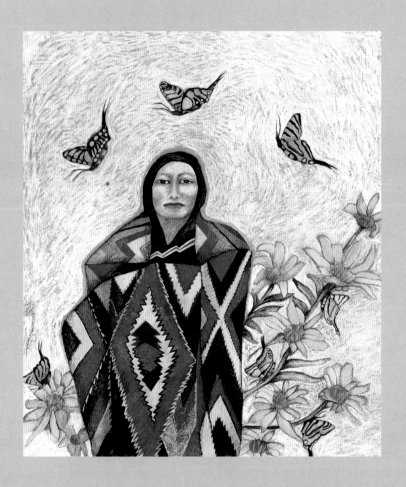

Patricia Wyatt.
Changing Woman,
1997. Collection of
the artist

Then he instructed her, "Follow closely; step where I step. Hold tight to my girdle; do not let go even for a moment. Do not look at any other butterfly until we are safely out of the valley. Obey me now and you will be safe forever. If you let go of my girdle even for a moment, I cannot protect you." They began the hard journey, going fast and straight. As they entered the Valley of the Butterflies, the air seemed entirely filled with butterflies. The butterflies beat their wings against the pair's arms and legs, fluttered in their faces and caught in their hair. Tolowim Woman held fast to Butterfly Man's girdle with downcast eyes, lest she look at another butterfly.

Suddenly a huge all-black butterfly hovered before her, grazing her breasts and moving into her line of vision. She closed her eyes for a moment so that she would not look at him, and he settled for a brief moment on her lips. Tolowim Woman was so startled that she opened her eyes and gazed at this huge butterfly, drinking in his beauty. As he began to move away from her she took one hand from Butterfly Man's girdle to reach for this black beauty, and he was gone. At once a hundred thousand butterflies danced before her, white, yellow, black, purple, gold, green, and orange. She reached for them all but could not catch them.

Butterfly Man never looked back. For a while she could see him running through this sea of fluttering beauty, and then he was gone. She ran after one and then another, always reaching, always missing. Disheveled, obsessed, her hair unbraided, her skirt ragged and her moccasins in shreds, she continued her hopeless chase until her heart stopped beating.

Tolowim Woman did not follow cosmic laws, betraying both her husband and her lover. She wanted to capture freedom and beauty, contain and hold them only for herself. For these reasons, her yearning for freedom never became realized and she was led down the path of destruction.

The caterpillar on the Leaf
Repeats to thee thy Mother's grief
Kill not the Moth or Butterfly
For the Last Judgement draweth nigh.
—William Blake

What the caterpillar calls the end of life the Master calls a butterfly.
—Richard Bach

The butterfly of death, Micpapalotl
(Ascalapha odorata)

The monk who decorated a fifteenth-century manuscript for Catherine of Cleves painted a death's-head moth, *Sphinx atropos,* in the upper left corner of the page devoted to Saint Vincent, who represents immortality and triumph over death. This species of moth is named for Atropos, one of the three Fates who mercilessly cut the thread of human life with scissors, and it is a large insect with a light yellow patch above its thorax that resembles a skull. Because of this inauspicious marking and the strident sound it makes while flying at night, the moth has been regarded as a messenger of death and a bearer of negative influences.

In classical mythology, the death's-head moth was believed to have originated in the underworld, Hades, whirring in restless flight along the inky streams of the River Styx, upon whose waters moved the heavily freighted barges of the dead. On its back the moth bears the seal of Hades for all men to see—the death's head. It is the ultimate witness of a night world of antiquity long past. Its terrible coat of arms reminds all men of death and of the vanished world of shades. Alone of all moths it is endowed with a voice, but what it says no living soul has ever understood.

One of the pharaohs of ancient Egypt had painted on his sarcophagus a large gold-and-black death's-head moth, its wings rigidly outstretched and the mark of death on its body. It was believed that the magical black moth banished evil spirits, ghosts, fearsome apparitions, and vampires. People called it the "father of the village." This species ranges from the eastern Caucasus and northern Persia through Ethiopia and Madagascar in the south and the Azores in the west.

In Mexico the black butterfly called Micpapalotl *(Ascalapha odorata)* is said to portend death if it lands on the door of a house. Its name derives from *miquiztli,* the Nahuatl word for death. The Dominicans have a similar belief of bad luck when a black butterfly visits a house, although a small white butterfly symbolizes good news, a blessing from God, and a sign that good luck is on its way. Colombians also believe in the superstition about black butterflies and death, but encountering a brown butterfly means that a lot of money will come to you and someone special will visit your house. (However, a brown butterfly in Ecuador means that someone is going to die.) The Goajiro people in Colombia believe if a certain large white moth enters a bedroom, it must be treated gently, as it probably is the spirit of an ancestor. If the moth acts annoying, it is with the greatest of care that one must usher it out of the house, because if one is not careful, the spirit of the ancestor will take revenge. The Aymara of Bolivia believe that a particular rare species of nocturnal moth is an omen of imminent death.

Book of Hours of Catherine of Cleves, *c. 1435. This detail of the page devoted to Saint Vincent shows a death's-head moth in the margin. J. Pierpont Morgan Library, New York*

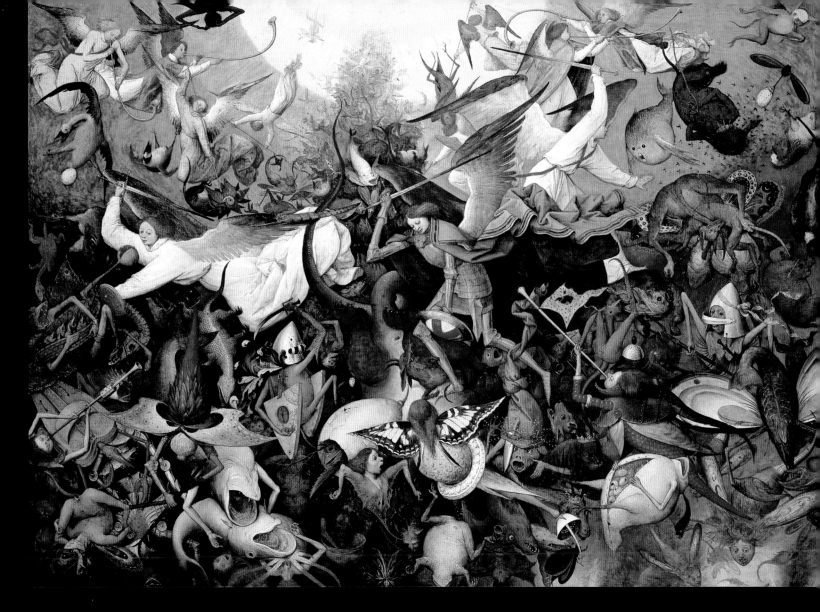

Pieter Bruegel the Elder. The Fall of the Rebel Angels, 1554. This Flemish master, inspired by the fantastical work of Hieronymous Bosch, has depicted Saint Michael fighting the rebel angels as they fall from heaven. Michael has killed the dragon of the Apocalypse, while his aides deal with throngs of strange creatures intertwined at their feet. Bruegel's placement of the beautiful butterfly wings in a prominent position in the painting may allude to the concept of rebirth or to the attractive qualities of evil. Musées Royaux des Beaux-Arts de Belgique, Brussels.

In Haiti there are many species of butterflies, but a large black one in particular is seen only when something special is going to happen. When someone in the house is sick and a black butterfly perches on the front door, it is likely that the sick person will die. On the other hand, if you see a black butterfly when your day begins, there is a chance that someone special will come into your life. Furthermore, if you cross paths with a black butterfly at any other time of day or night, a terrible feeling may overcome you, because this means someone close to you is likely to become seriously hurt. In the Philippines, when Ferdinand Marcos died, headlines in newspapers reported that a black butterfly had been seen entering the castle just before his death.

Certain European butterflies are also viewed as omens of death. For the Gnostics, a butterfly was the symbol of corrupt flesh, a sentiment reflected in Breugel's painting of the rebel angels. Black butterflies don't have a very good reputation in Bulgaria, where seeing one means that death or sickness is near. In the East Indies hordes of butterflies are believed to predict disease or famine.

In Westphalia, Romania, Albania, and Lithuania, it was once believed that butterflies helped to spread the plague. Romanians have also believed that if a moth flies into someone's eye, he will be blinded, and in Bohemia, it is thought that the first person to see a red butterfly in the spring will develop an illness related to his eyes. Another Romanian superstition holds that if a butterfly is killed, the heart of the maid from whose tears the butterfly was created will be broken.

In parts of England, it is bad luck to see more than three butterflies in a group, and in Scotland, it is unlucky to keep or kill a butterfly. At least until the early part of the twentieth century, butterflies were fed with honey in western Scotland to honor their sacredness.

Vincent van Gogh. Death's Head Moth, 1889. Van Gogh often painted flowers and insects (see page 80), usually without theme or symbolic meaning, but this picture of a moth, painted at Saint-Rémy the year before he died, is not a pretty image but dark and somewhat sinister. The artist wrote to his brother that he had been obliged to kill the moth in order to paint it and called the creature a "very big, rather rare night moth, called the death's head." He has incorporated the features of a skull into the body of the moth, which may resemble the artist's own image. Van Gogh Museum, Amsterdam

> Butterflies are white and blue
> In the field we wander through.
> Suffer me to take your hand.
> Death comes in a day or two.
>
> All the things we ever knew
> Will be ashes in that hour:
> Mark the transient butterfly.
> How he hangs upon the flower.
> Suffer me to take your hand.
> Suffer me to cherish you
> Till the dawn is in the sky.
> Whether I be false or true,
> Death comes in a day or two.

—Edna St. Vincent Millay

There are no butterflies poisonous to humans or other large animals. An exception is the fluid from the caterpillar of an African moth, which is used to poison the tips of arrows that can kill an antelope quickly. It is mostly birds, who are predators of butterflies, that face danger with some species. Butterflies whose caterpillars eat milkweeds, pipe vines, or passion vines are either distasteful or poisonous to most birds, causing them serious gastrointestinal distress or even killing them.

James Ensor. Small Bizarre Figures, *1888. Working in Belgium in the late 19th century, Ensor was known for his grotesque portrayals of humankind, influenced by Hieronymous Bosch and Pieter Bruegel the Elder. Skeletons were not uncommon in Ensor's work, but the butterfly rising with a skull above is unusual in this strange etching. The dark butterfly above the head of the woman (who appears at several ages) and beneath the image of a skull seems to be accompanying her to death, while the man, also depicted at different ages, makes a pact with the Devil. Fine Arts Museums of San Francisco. Achenbach Foundation for the Graphic Arts, Gift of John Gutmann in memory of Walter Heil*

The butterfly counts not months
 but moments
 and has time enough.
 —Rabindramath Tagore

I only ask to be free. Butterflies are free. Mankind will surely not deny to [me] what it concedes to the butterflies.
 —Charles Dickens

I once met a woman who had been a child of four at the start of World War II. Her Jewish family had fled Germany and was hidden by French farmers. Near the house in which they stayed, down a six-foot embankment, was a creek where the children were allowed to play among the flowers and rocks and fast-flowing water. And here were butterflies. Sometimes the children would catch them, show them to the adults, and then let the butterflies fly free. These were the happiest years of my friend's life, which she remembers as being full of beauty, freedom, and laughter. In later years, she would feel guilty about that time of her life, because she was happy while so many millions were suffering and dying.

 When the children came up from the stream, they would bring with them more than colorful butterflies and laughter. They brought joy and hope and a glimmer of light to their families and that gave them all courage, a hint of normalcy, a special moment in the midst of a dark war. Without the children's laughter and lightness, there would have been only despair. The butterfly is the symbol of that light. When we see a butterfly, it stirs the magic and wonder within, awakening and stirring our hearts and spirits. And a world without butterflies would be a world without hope.

 The following poem was written by twenty-one-year-old Pavel Friedman while he was living in a Jewish ghetto, Terezin, in Czechoslovakia in 1942, when he recognized that a world that hates, destroys, and kills children, a world devoid of butterflies, is a world without hope. He died in a Nazi concentration camp two years after he wrote the poem:

I NEVER SAW ANOTHER BUTTERFLY

The last, the very last,
so richly, brightly, dazzlingly yellow,
perhaps if the sun's tears would sing
against a white stone.

Such, such a yellow
is carried lightly 'way up high.
It went away I'm sure because it wished to
kiss the world goodbye.

Audrey Flack. World War II, Vanitas, *1976–77. The artist has written that she contrasted the faces of prisoners, adapted from Margaret Bourke-White's photographs of the liberation of Buchenwald, with images of indulgence, portraying both beauty and horror in the spirit of Bruegel. She included butterflies to represent the liberation of the soul.*

A field of 1,300,000 paper butterflies representing children killed in the Holocaust made by students in Myrtle Beach, South Carolina

For seven weeks I've lived here,
penned up inside this ghetto,
but I have found my people here.
The dandelions call to me
and the white chestnut candles in the court.

Only I never saw another butterfly.

That butterfly was the last one.
Butterflies don't live in here,
in the ghetto.

In January 1998, a group of children from Chabad Academy, a private school in Myrtle Beach, South Carolina, was studying the Holocaust with their teacher, Eleanor Schiller. The students learned how many children were exterminated, and because numbers are so impersonal, they decided that they wanted to remember the murdered children as individuals by making a paper butterfly to represent each child who died. In order to achieve their goal, they would have to create 1,200,000 paper butterflies before April 23, Holocaust Remembrance Day. By February they had created 8,000 butterflies, and they knew they needed help. Eighteen teachers and their students from local schools participating in workshops on the Holocaust created thousands

OPPOSITE:

Vincent van Gogh. Prisoners in the Courtyard, *1890. In this deeply symbolic painting of a prison courtyard, two little butterflies hover above the circle of prisoners; they are a presence of hope in a scene of overwhelming oppression, the messengers of spirit and light penetrating the dark recesses of our own prisons, be they internal or external. The prisoner facing the viewer is a self-portrait. Pushkin Museum, Moscow*

more butterflies, but even these were not enough. The students reached out to news organizations, which quickly spread the word to other children and teachers, and by the deadline, they had made or received from other students more than 1,300,000 butterflies, which they attached to wooden sticks. The fields and meadows were blanketed with the multicolored butterflies, the spirits of the dead children. One of the students was heard to say, "Butterflies are like children, full of color." She might have added: and full of spirit.

Dr. Elisabeth Kübler-Ross, a doctor widely known for her work on death and dying, described in her book *The Wheel of Life: A Memoir of Living and Dying* a journey she made to the site of the Majdanek concentration camp in Poland shortly after World War II. She visited the children's barracks, where she encountered clothes and little shoes tossed

Henry Darger. Keep Quiet. *Darger was a troubled orphan who lived most of his life in his prodigious imagination. His magnum opus of about 15,000 pages, entitled* The Story of the Vivian Girls in What is Known as the Realms of the Unreal or the Glandelinian War Storm, *was created over a span of 60 years, from the 1920s until his death in 1973. The seven heroine sisters, who have butterfly wings, are freeing children from slavery. Nathan and Kiyoko Lerner Foundation*

aside, but she also saw something that at first surprised and then amazed her. Carved into the walls with pebbles and fingernails were butterflies, hundreds and hundreds of them. Spellbound by the sight of butterflies drawn on the wall, she couldn't help but wonder why they were there and what they meant. Twenty-five years later, after listening to hundreds of terminally ill patients, she finally realized that the prisoners in the camps must have known that they were going to die. "They knew that soon they would become butterflies. Once dead, they would be out of that hellish place. Not tortured anymore. Not separated from their families. Not sent to gas chambers. None of this gruesome life mattered anymore. Soon they would leave their bodies the way a butterfly leaves its cocoon. And I realized that was the message they wanted to leave for future generations. . . . It also provided the imagery that I would use for the rest of my career to explain the process of death and dying."

Perhaps not coincidentally, there are accounts of thousands of butterflies having alighted on Auschwitz, Majdanek, and other death camps for years after the Holocaust. Souls, free at last.

We have seen the magic of the butterfly spirit at work, in both sacred and profane circumstances, but in the hands of the Surrealist artist Salvador Dali (who ate butterflies as well as admired them), we see the butterfly itself invoked to lend its magic to that of the Tarot cards, which are used for divination and guidance. He created a series of seventy-eight cards and in sixteen of them integrated butterflies—powerful symbols of spiritual transformation—into the design, along with references to well-known works of art, letters of the Hebrew alphabet, and astrological symbols.

The Fool is the first card of the deck and like many classical heroes is born of both divine and mortal parents. He must face many difficulties in his eternal quest to overcome the forces of darkness in order to attain the goal of truth and awareness. He must conquer death and be reborn. Here the butterfly and the butterfly-winged horse act as his guide and help him navigate obstacles on his way.

Love is the first trial in the Fool's adult life, and the lovers here are Adam and Eve (based on a print by Albrecht Dürer), who represent the dangers and pitfalls inherent in making all choices, particularly in the name of love. Cupid here has butterfly wings and his genitalia are hidden behind a butterfly, perhaps because love is not a decision to be made only on a physical level.

Dali's version of the Devil is both male and female and carries a butterfly wand. The Devil teaches the Fool to respect and accept all aspects of his nature, both the darkness and the light. The Christians turned the ancient god Pan into the Devil, for he represented untamed nature and sexuality. It is only by facing our shadows that we can become whole, for to deny them is to stunt our potential for wholeness and growth and balanced energy. As the Fool begins to accept his shadow, he gains more compassion and tolerance for himself and for others. Butterfly energy helps him to transform negative energy into the positive.

The Fool must learn to balance the mind with the heart. This card, Temperance, depicts an angel with butterfly wings pouring the waters of emotion from a golden cup (consciousness) into a silver cup (unconsciousness), showing that life alternates between these two states. Temperance teaches how to balance the opposites of success and failure, growth and decay, joy and sorrow. It also represents the qualities of compassion and forgiveness in the search for emotional equilibrium.

Judgment is the penultimate stage of the journey for the Fool. The path of spiritual growth is, as the Buddhists say, through the reconciliation of opposites. The butterfly-winged figure, Christ, is rising from his tomb, indicating spiritual rebirth and the immortality of the soul. The angel blowing the horn is a guide for souls rising to a level of greater wisdom, acceptance, and understanding. Neither self-inflated ego nor merciless self-recrimination will lead to our goal of wholeness. With butterfly wings we can soar to great heights.

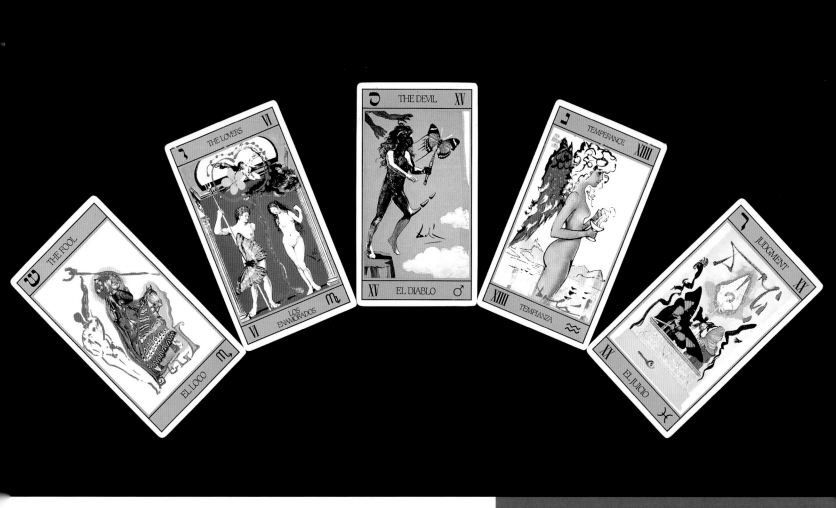

Salvador Dali. Tarot Cards, 1978. Left to right: the Fool, the Lovers, the Devil, Temperance, and Judgment. These cards, based on original paintings made for the James Bond film "To Live and Let Die," were published as lithographs in 1970–74.

The Artful Butterfly

A bird, a beetle, a butterfly call for the same rapt contemplation that we reserve for a Tintoretto or a Rembrandt.

—Claude Lévi-Strauss

The caterpillar can weave around itself a new dwelling place with marvelous artifice and fine workmanship. Afterwards it emerges from this housing with lovely painted wings on which it rises heavenward.

— Leonardo da Vinci

As we have seen, the butterfly has made frequent appearances in the history of art as a sacred or symbolic image, but much of its appeal as a visual element in works of art owes as much to the creature's variety and pure beauty as to its meaning. For millennia painters have depicted the butterfly as part of the natural landscape, sometimes for scientific purposes but often as a decorative image in combination with flowers, birds, and even humans. Butterflies have also been used to decorate objects as different as jewelry and furniture, from the most sacred to the least, sometimes for their symbolic value, sometimes for their beauty, and sometimes for both. Butterfly patterns vary enormously, which gives license to virtually every artist who chooses to depict them, but most butterfly images share a certain delicacy, grace, and striking beauty, presumably what attracted the artist in the first place. The vagaries and vanities of the fashion world have swept the butterfly up into its net, where lepidopteran colors and patterns have helped to enhance the beauty of both men and women.

Butterflies have been subject to fads as well as fashion, and it may not be purely coincidental that the last decade of both the nineteenth and the twentieth centuries saw an emergence of butterflies nearly as impressive as the Mexican Valley of the Butterflies in November. Whether this was the result of a sense of anxiety about the end of an era or a feeling of hope for the future, we may never know, but the popularity of the butterfly form is a fascinating spectacle to observe. In this section, devoted to the beautiful rather than the sacred, let us allow the butterfly to be our guide to the spirit of the artist.

Antonio Canova. Cupid and Psyche, *1796–1800. The love story of Cupid and Psyche, although a second-century Roman fairy tale likely based on a Greek source, was brought back to life in 18th-century Rome by this prominent Neoclassical sculptor, whose works in marble were inspired by the sculpture of classical Greece and Rome. The Louvre, Paris*

The Illustrated Book

Hand-drawn calligraphic scrolls and books have been in existence since the Egyptian Book of the Dead but the art of illumination reached its peak in western Europe in the manuscripts of the Middle Ages. Few Early Christian and Byzantine manuscripts have survived, but by the eighth century, many biblical, historical, and literary manuscripts were created in monasteries for royal and ecclesiastical patrons. Some monks became masters of calligraphy while others specialized in painting miniature scenes of great beauty. Others monks were given the task of decorating margins with floral or vegetal designs, often animated with birds, butterflies, and other insects that may bear little connection to the text.

Joris Hoefnagel. Folio 96 of Mira calligraphiae monumenta, *1591–96. By the 16th century, the tradition of accurate representation in manuscripts gave way to artistic license. The images on this page from a manuscript devoted to the subject of calligraphy look realistic, but in fact both the butterflies and the moth are imaginary. (In nature, a moth's antennae are usually fernlike, whereas a butterfly's are clubbed on the tips.) J. Paul Getty Museum, Los Angeles*

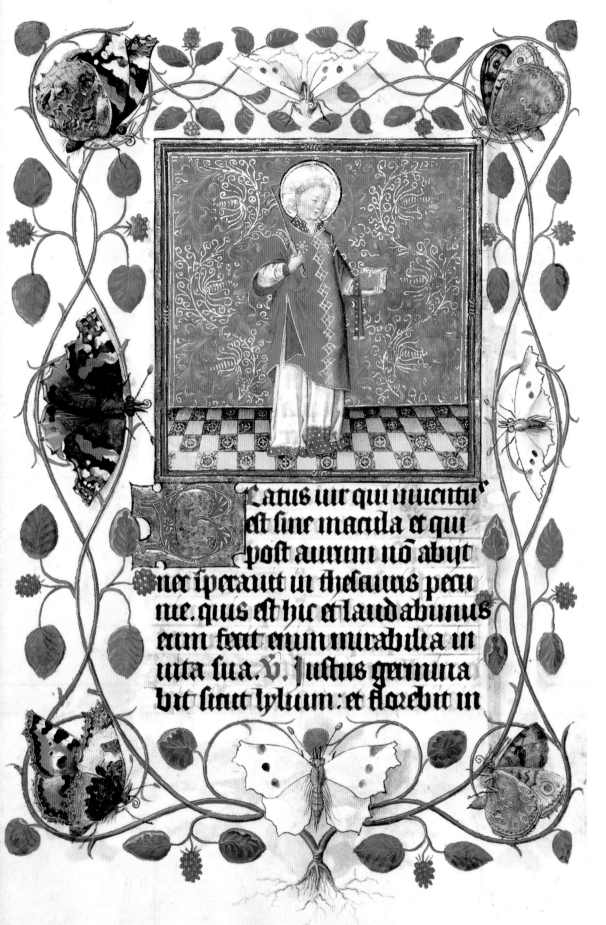

Book of Hours of Catherine of Cleves, *c. 1435. A number of the most beautiful illuminated manuscripts created in medieval Europe were books of hours, consulted for the correct prayer to be offered at the appropriate hour of the day or time of year. In this Book of Hours made for Catherine of Cleves, the artist chose to represent a death's-head moth, perhaps as a reference to Saint Vincent, to whom this page is dedicated (see page 64), but the other butterflies on the page seem to have little if any symbolic relevance. The butterflies are painted with great accuracy, indicating that the monk may have used actual specimens as models. J. Pierpont Morgan Library, New York*

Kubo Shunman. Tsubasa ni wa . . . *from the* Illustrated Collection of Butterflies, *1804–18. This handsome woodblock print is part of the Japanese tradition of natural-history illustration that includes prints by such well-known artists as Hiroshige and Utamaro. Borrowing from the Chinese in combining calligraphy and visual images, this artist has depicted several species of butterfly, along with a poem describing their beauty in flight. Fitzwilliam Museum, University of Cambridge, England*

William Blake. "Infant Joy," from Songs of Innocence,
*1789. Blake relied on his own imagination as well as
on tradition to create brilliant images in his unique
hand-colored prints that incorporate both verse and
pictures. Here he has used the image of Psyche as a
flower pistil to symbolize a fertilizing force welcoming
new life. Huntington Library, Art Collections, and
Botanical Gardens, San Marino, California*

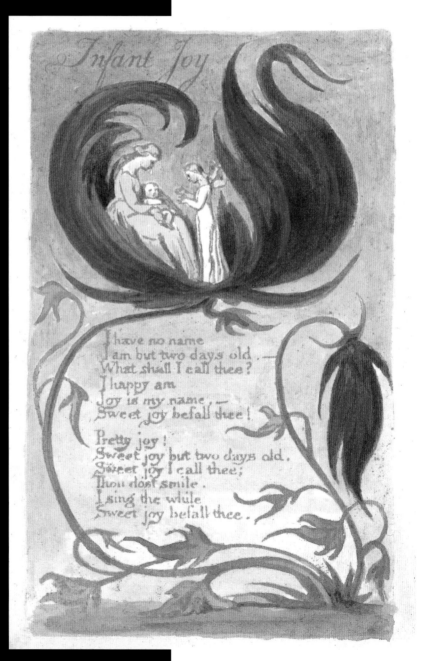

Anonymous Chinese artist. Butterflies and Blue Flowers, 18th century. The Chinese tradition of flower painting, which began over a thousand years ago in the Five Dynasties of the 10th century, has always been remarkable for its elegance and accurate rendering, in spite of differences in style and technique. This 19th-century Chinese watercolor looks much more like a European illustration of the same period than a traditional Chinese work, in which meanings are usually attached to certain flowers. Butterflies depicted with a peony means longevity, whereas beauty in old age is a butterfly with a chrysanthemum. Victoria & Albert Museum, London.

Pablo Picasso. Le Papillon, 1941–42. Although Picasso can surely be considered the most innovative of modern artists and one of the earliest to reduce natural images to abstract forms, he always came back to nature at various points in his long career. This beautiful still-life print of flowers and butterflies indicates that Picasso, like many of his generation, was influenced by traditional Chinese art, but this image is well established in the European tradition, for it is in a series of illustrations that Picasso made for texts by the Comte de Buffon, an important naturalist of 18th-century France (see page 99). Fine Arts Museums of San Francisco, Achenbach Foundation for Graphic Arts, Bequest of Bruno Adriani

Vincent van Gogh. Butterflies and Poppies, *1890. This Dutch
painter also liked to paint still lifes, which apparently helped to calm
his nerves. Unlike his disturbing picture of a death's-head moth
(page 66), this small, quickly painted canvas shows van Gogh's
ability to capture the natural, delicate beauty of these red poppies
and yellow butterflies without any obvious emotional overtones.
Like many other artists of his time, van Gogh was influenced by
Japanese art, in which butterflies and flowers were popular subjects.
Van Gogh Museum, Amsterdam*

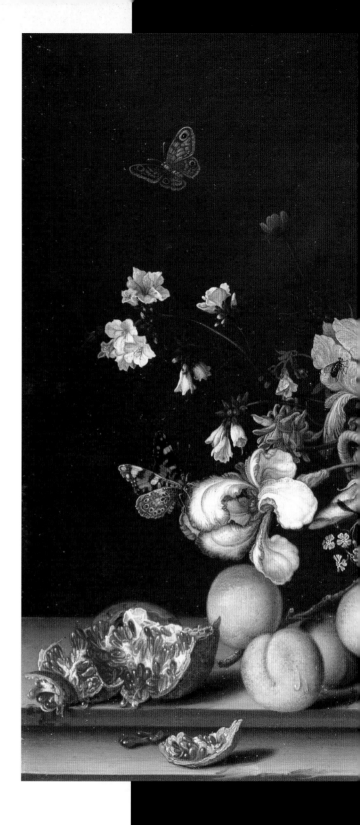

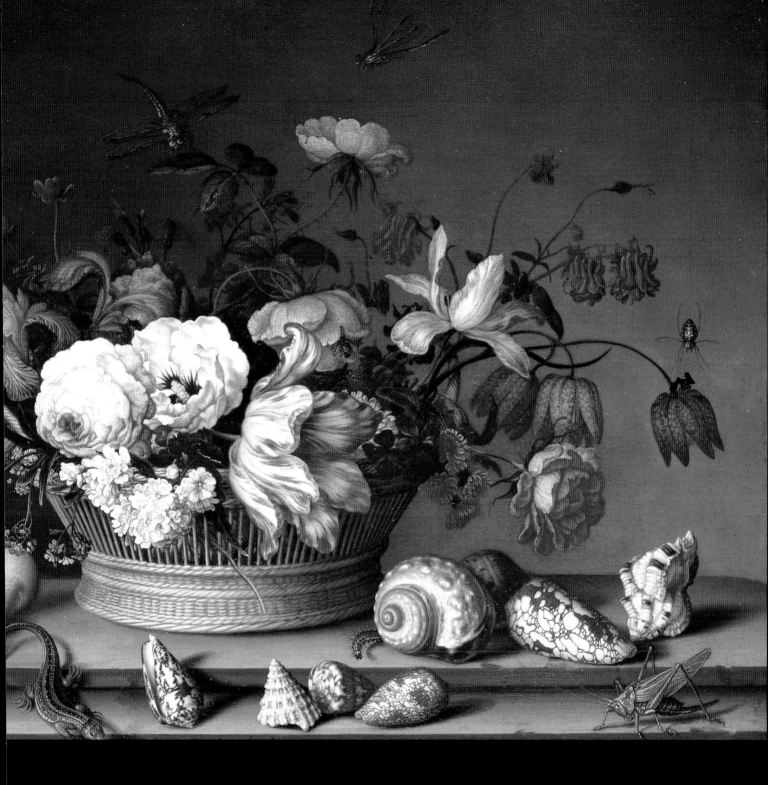

Balthasar van der Ast. Still Life with a Basket of Flowers, *17th century. Flowers were a popular subject in Dutch and Flemish painting; in fact, it is said that the Dutch created the demand for paintings of flowers, because the real ones were too expensive. Often these flower paintings were part of the tradition of Vanitas painting, which combined various symbols of the transient and cyclical nature of life on earth. Van der Ast included Europe's largest species of hairstreak butterfly, a symbol of immortality, among the soon-to-be-faded flowers, and empty seashells are a reminder of the inevitability of death and the vanity of earthly achievements and pleasures. Statens Konstmuseer SKM, Stockholm*

This Japanese robe was made as a costume for a Noh drama in the 19th century, when the 17th-century embroidered butterflies were sewn onto the silk fabric. The Metropolitan Museum of Art, Gift of Alice Boney

Ko-cho dancer. The Japanese have a traditional butterfly dance, called Ko-cho no Mai, which duplicates the erratic fluttering of the butterfly in flight. This late-19th-century illustration of a butterfly dance shows that the elegance of the dancer's movements was significantly enhanced by the design of the traditional costume she wore. Japan Society, New York

A free-spirited American dancer, choreographer, actress, and playwright, Loïe Fuller arrived on the scene in Paris in 1893. A pioneer in the world of modern dance, she performed her sensual creations at the Folies-Bergère, where both Henri de Toulouse-Lautrec and Auguste Rodin were captivated by her and used her as a subject in their work. As she experimented with the effects of colored electric lights and silk scarves and costumes, she became known as the Goddess of Light. One of her best-known and most imitated dances was "Papillon, or the Dance of the Butterflies." It may have been Loïe Fuller's example that inspired one of Marcel Marceau's most beloved pantomimes, known as the Butterfly. Bibliothèque Nationale de France, Paris

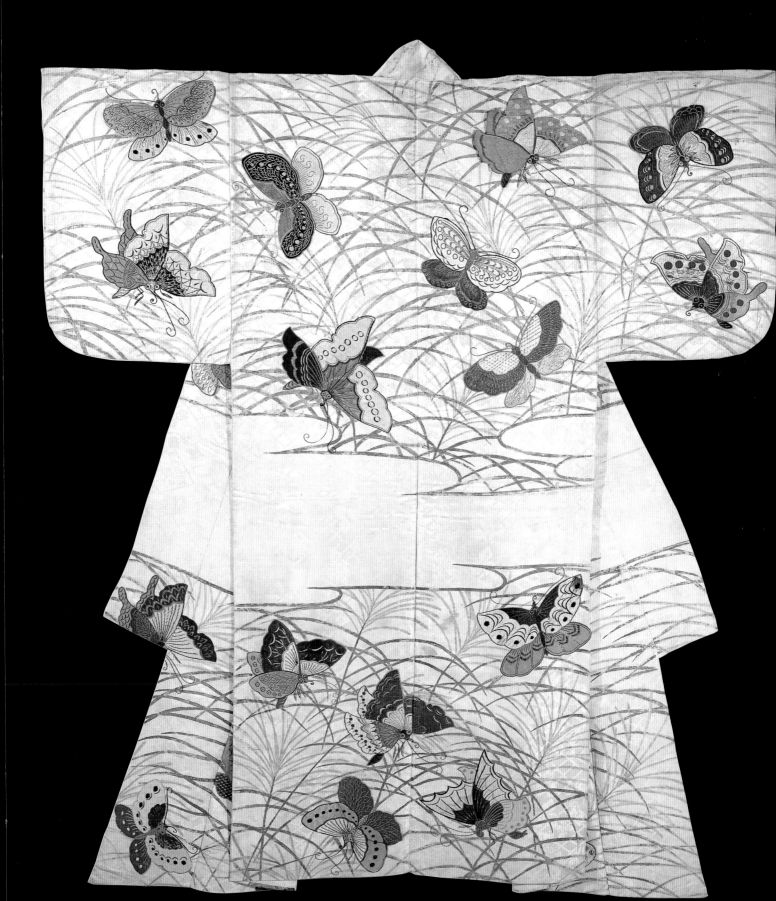

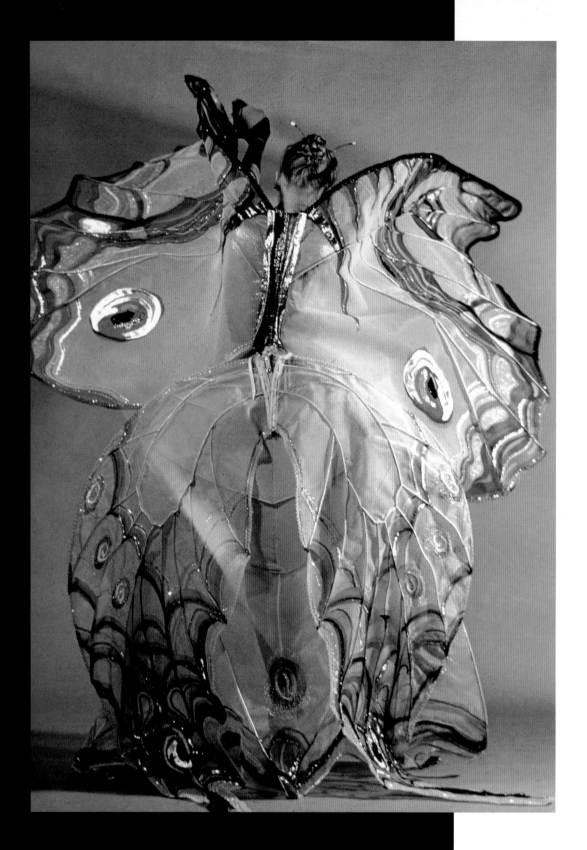

Willa Kim designed the costumes for Eliot Feld's dance "Papillon" (1979).

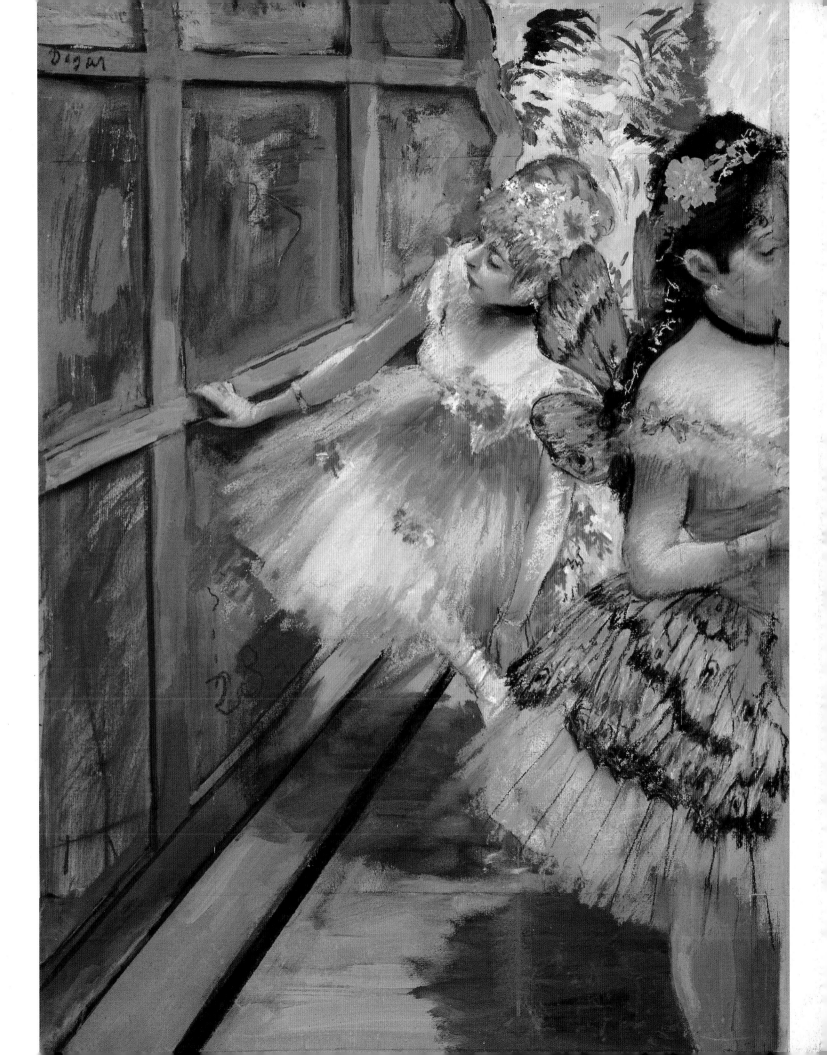

Myth

This legend from the Papago Indians of California explains why butterflies cannot sing:

One day, while the Creator was resting, he watched a group of children playing in a village. The children laughed and sang, yet the Creator's heart was sad. He was thinking that these children will grow old, their skin will become wrinkled, their hair will turn gray, their teeth will fall out, and they will become blind and weak. The young hunter's arm will fail. These lovely girls will grow ugly and fat. The playful puppies will become blind, mangy dogs. And those wonderful flowers of all colors, red, purple, blue, and yellow, will fade. The leaves from the trees will turn colors, then fall and dry up. Thus the Creator grew sadder and more despondent. It was in the autumn, and the thought of winter, with its treacherous cold and lack of game and green, made his heart heavy.

Yet it was still warm, and the sun was shining. The Creator watched the play of light and shadows on the earth, and the multicolored leaves being carried by the wind. He noticed the blue, blue sky and the whiteness of the ground, like cornmeal. He smiled as he realized that all those colors could be preserved. I'll make something to gladden the hearts of the children and my own heart, something to bring beauty and lightness of spirit to the world.

The Creator took out his bag and started gathering things: a spot of sunlight, a handful of blue from the sky, the shadows of playing children, the blackness of a beautiful girl's hair, the yellow and red and orange of falling leaves, the green of pine needles, and the many colors of the flowers. All these he put into his magic bag. And, as an afterthought, he put in the songs of the birds.

He walked to where the children were playing and offered them his bag, urging them to open it because there was something special inside. The children opened the bag and immediately hundreds and hundreds of brightly colored butterflies flew out, dancing around the children, settling on their noses, and their hair and flying from flower to flower to drink the nectar. The enchanted children had never seen anything quite so beautiful and magical before.

The butterflies began to sing and the children were doubly entranced. But then a songbird flew to the Creator's shoulders, scolding him. "It's not right giving our songs to these new pretty creatures. You told us when you made us that every bird would have his own song. And now you have given away our songs. Isn't it enough that you have given these new creatures the colors of the rainbow?"

"You're right," said the Creator. "I made one song for each bird and I should not have taken what really belongs to you alone." So the Creator took the songs away from the butterflies, and that's why they are exquisitely beautiful, but silent to this day.

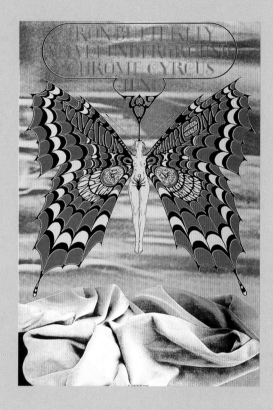

Bob Schnepf. The Family Dog & Bill Graham presents Iron Butterfly, *1968. The 1960s were known as a time of freedom and this poster advertising Iron Butterfly at the Avalon Ballroom in San Francisco captures the spirit of the butterfly in an era of spiritual and artistic exploration. Fine Arts Museums of San Francisco, Achenbach Foundation for Graphic Arts*

It has no voice, the butterfly, whose dream of flowers I fain would hear.
—Japanese haiku

In spite of its inability to sing, the butterfly has been the subject of much musical artistry: Maria Callas as Cho Cho San in *Madama Butterfly,* Sarah Vaughan and Carmen McCrae with their renditions of "Poor Little Butterfly," Ella Fitzgerald and Bobby Short singing Duke Ellington's "Black Butterfly," Carman McCrae doing Thelonius Monk's "Little Butterfly," Mariah Carey with "Butterfly," Bobby Carlisle's "Butterfly Kiss," Luther Vandross and Chaka Khan's "Chanson Papillon," Bruce Woody's "Flight of the Butterfly" (dedicated, incidentally, to me), Russell Malone's "Black Butterfly," the rock group Iron Butterfly, and Native American music accompanying various butterfly dances.

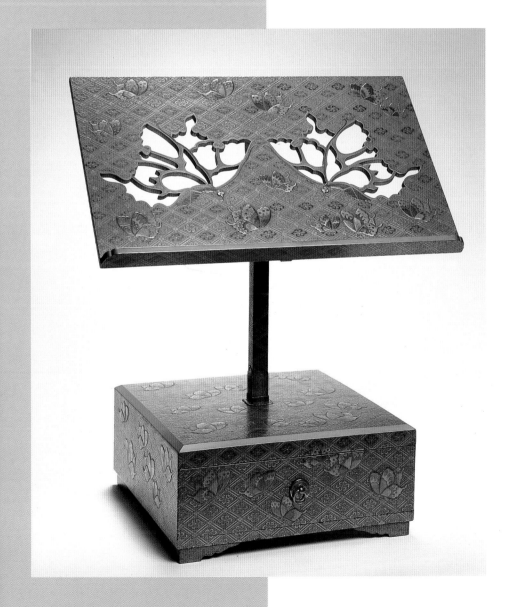

The designer of this lovely 17th-century Japanese music stand was clearly inspired by a butterfly, in spite of its silence. Lacquered wood with silver and mother-of-pearl inlay. Asian Art Museum of San Francisco, Avery Brundage Collection

The Butterfly Collector

Victorians were known for their butterfly collections, in which dead specimens from all
corners of the world were neatly organized and arranged under glass, sometimes in the
name of science and sometimes as a personal obsession. (Often the two were combined;
see pages 126–30). This collecting craze clearly bothered Edmund Dulac, who was at
the turn of the twentieth century one of the most celebrated illustrators of gift books,
including books of fairy tales, the story of Cupid and Psyche, and *The Tempest.* As an
entomologist sleeps, the souls of butterflies he tried to capture return to life to haunt his
dreams, because their souls could not be contained in death. In his macabre novel *The
Collector,* John Fowles gave butterfly collecting a similarly sinister twist by having his
main character "collect" a young woman who had attracted his fancy.

Edmund Dulac. The Entomologist's Dream, *1909.
This drawing was used to illustrate a fantasy called
"Le Papillon Rouge," which appeared in
L'Illustration, a Parisian magazine, in 1909.
Victoria & Albert Museum, London*

Winslow Homer. Butterflies, 1878.
The sport of butterfly netting was
still a popular diversion centuries
later, especially for young women,
who made very appealing subjects
for artists who chose to paint
out-of-doors. Winslow Homer was
painting in America at about the same
time that Berthe Morisot, one of
the French Impressionists, depicted the
same subject. In both pictures
the spontaneous application of paint
and their interest in the effects of
light and color on form lend an
appropriate delicacy to the subject
of catching butterflies. New Britain
Museum of American Art,
Connecticut

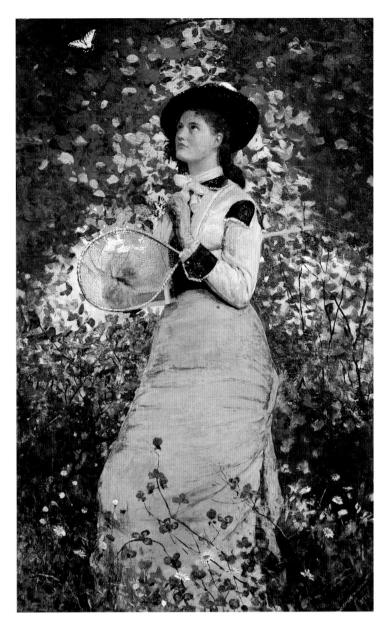

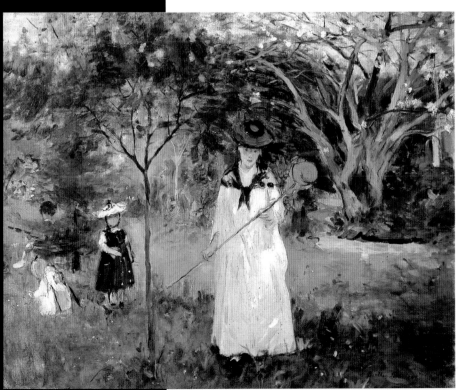

Berthe Morisot. The Butterfly Hunt,
c. 1865. Musée d'Orsay, Paris

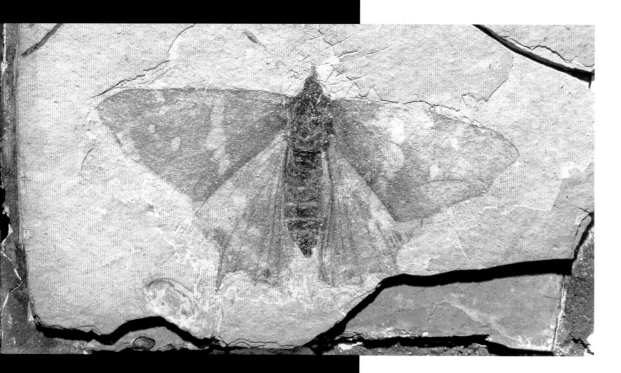

Not all collected butterflies end up pinned to boards and put away in drawers. This beautiful image is not, in fact, a work of art but a fossil of a butterfly that was killed by volcanic ash more than 70 million years ago in what is now the state of Colorado. Ernst Mayr Library of the Museum of Comparative Zoology, Harvard University, Cambridge

Pablo Picasso. Composition au papillon, 1932. The elegant and fragile beauty of this dead butterfly must have had a special appeal for Picasso, the preeminent 20th-century master who was one of the first artists to use collage in the modern era. Musée Picasso, Paris

B. WILKES del. PLATE VIII.

1. The White Admirable Butterfly, to be taken in the Fly State about the 20.th of June, in Comb-Wood. 2. The Drinker Moth.
The Caterpillar feeds on long Grass, changes to Chrysalis the end of May, the Fly appears the end of June. 3 The Lime
Hawk Moth. the Caterpillar feeds on Elm, Lime &c. changes to Chrysalis in July, the Moth comes forth in April. 4 The
Eyed Hawk Moth. the Caterpillar feeds on Willow. changes to Chrysalis in August, the Moth appears in May. 5. A
White Striped Moth, taken by beating the Hedges in May. 6 The Mottled Umber, a Moth. The Caterpillar feeds on Oak
changes to Chrysalis about July, the Moth appears in October.

Printed for Carington Bowles, N.º 69 S.t Pauls Church Yard, London.

Benjamin Wilkes Bowles published this hand-colored plate in his Twelve Designs of English Butterflies, 1742.
Many naturalists chose to publish their butterfly collections in books, whose illustrations were often hand-colored
engravings and are now collector's items themselves. Many of these books are invaluable scientific references; others
are innovative and amusing. A number of prominent nature-science illustrators of the 18th and 19th centuries
breathed life into their subjects by placing them in natural settings, surrounded with flowering plants, but some
tried to evoke the collector's board by placing specimens in patterns on the page. British Library, London.

Myth

Why the Butterfly Has Rings on Its Wings

Once upon a time a rumor spread through Palestine that there was a man who could perform greater miracles than God. Hearing of this, Saint Anne decided to go and see him, and so she did. When she approached the house where he lived, she washed her feet, as is customary in those parts of the world, and with meekness and devotion she asked the man to change a withered trunk into a green tree. The man got very angry, and said he did not perform miracles. After insulting her before the assembled multitudes, he seized her hands and thrust her out of his house.

When Saint Anne saw what he had done, she fell upon her knees and prayed to God to punish the man. As she was lifting up her hands in prayer, she suddenly noticed that the ring her dear mother had given her was gone. She remembered that the man had taken hold of her hands and realized that he must have slipped the ring off her finger. So she prayed that God would punish this impostor and thief.

God heard her prayer. All of a sudden, the man disappeared from among the people, and a small ring appeared around one of the boughs of the tree outside the house. While the people were gazing upon this ring into which the thief had been changed, it opened and out of it came a hundred small butterflies with the mark of the ring on their wings. This was the sign of the ring that had been stolen from Saint Anne.

M. C. Escher. Butterflies, *1930. This Dutch graphic artist, famous for his witty manipulation of graphic images, was intrigued by the infinite, which must have influenced this interpretation of butterflies, whose wing patterns seem endless in their variety.*

Kjell Sandved. Close-up photograph of Elenia icarus. *The butterfly has appealed to artists over the years for the incredible beauty and variation of their wing patterns, not only from species to species, but also within a single butterfly. For example, the fore- and hind-wing patterns of each butterfly are different, as are the upper and lower surfaces, and are made up of tens of thousands of tiny overlapping scales. Each scale is a hardened one-celled point of color, which blends optically with other scales to make glorious patterns, the same principle that Georges Seurat applied to his Pointillist paintings. The wing patterns of all butterflies are variations on similar themes, such as spots, stripes, or borders, arranged in infinite variety. The master of butterfly photography, Kjell Sandved, has captured thousands of these varieties all over the world.*

Butterfly Spies

Just before World War I several patriotic young German naturalists descended on the French countryside with butterfly nets, catching specimens and sketching wing patterns to take back to Germany. Encrypted in the patterns of the butterfly wings were maps of vital strategic information, such as exact location of bridges and roads. French residents in the area, however, were knowledgeable about their local butterfly species and soon realized that the wing patterns in the drawings were incorrect. Thus the spies were exposed before they were able to send their information back to headquarters.

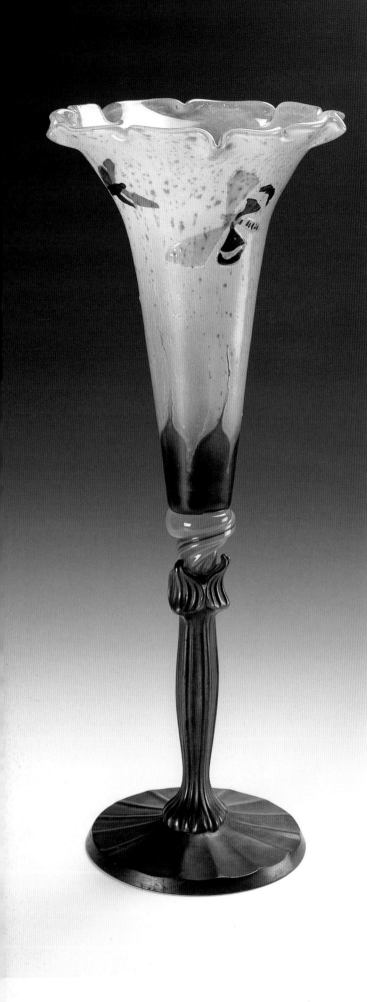

Émile Gallé. Vase à bague médiane, 1889. *The butterfly became increasingly popular as a decorative element toward the end of the 19th century in Europe, as many artists and designers were drawn to its shape, pattern, and meaning during a period that placed a premium on natural form, aesthetics, and symbolism. Émile Gallé was especially fond of butterflies and used them often in his work. The son of a glass-maker and ceramist, Gallé began creating works of art for his father at a young age; he also studied Islamic and Venetian glassmaking techniques and was inspired by the science of botany and the art of Japanese prints, like many of his contemporaries. In 1901 he founded the École de Nancy, a school dedicated to the international style of Art Nouveau, of which he was one of the most prominent proponents. Musée de l'École de Nancy, France*

Bernard Wolff. Butterfly, 1981. *This modern example of the art of cut and polished crystal was made for Steuben Glass. The butterfly shape mesmerizes us, like a mandala, as it evokes the infinite fascination with transformation.*

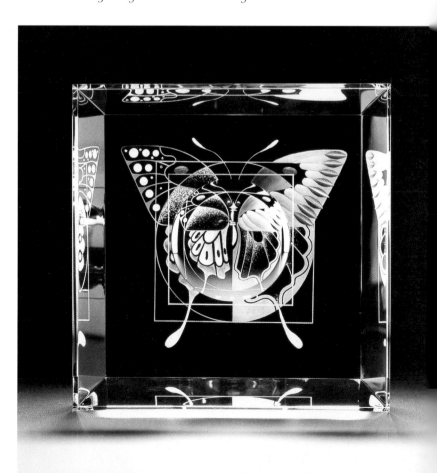

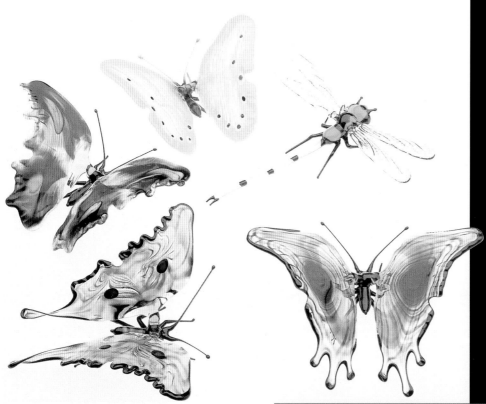

Vittorio Costantini. Butterflies and Dragonfly, *1979–80. Collection of the artist*

Leopold and Rudolf Blashka. Centauria cyanus. *In 1886, the director of Harvard's Botanical Museum traveled to Dresden in search of glassmakers who could accurately reproduce floral specimens in three dimensions to be studied by botany students during the long, cold New England winters. He found there a father-and-son team, Leopold and Rudolf Blashka, descendants of a family that had been making glass objects since the 15th century. Between 1887 and 1936 the Blashkas made more than three thousand exceptionally beautiful, accurate glass models illustrating the world of plants. The Botanical Museum of Harvard University, Cambridge, Massachusetts*

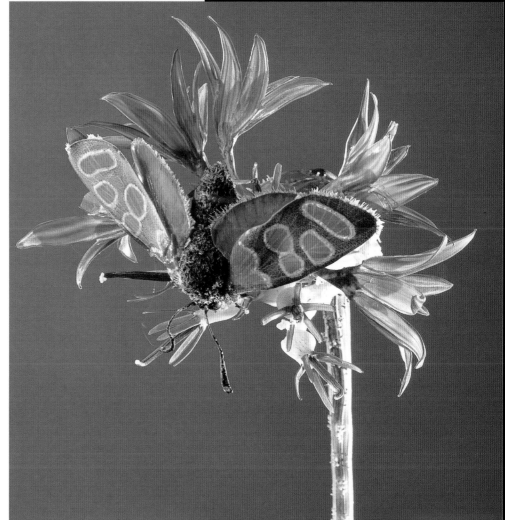

ABOVE AND LEFT:
*Émile Gallé. Aube et Crépuscule [Dawn and Dusk], 1904.
Émile Gallé is best known for his masterpieces in glass, but he
also turned his hand to furniture design. This opulent and
sensuous piece, created in 1904 as a marriage bed, surrounds
the sleeper with the nocturnal flight of exquisite moths flying
over a mysterious landscape and seems to invite the dreamer
to join the journey. Musée de l'École de Nancy, France*

OPPOSITE:
*Riccardo Dalisi. Mariposa Bench, 1989. This
bench is actually a functional work of butterfly
sculpture. Musée des Arts Décoratifs de Montréal,
The Liliane and David M. Stewart Collection*

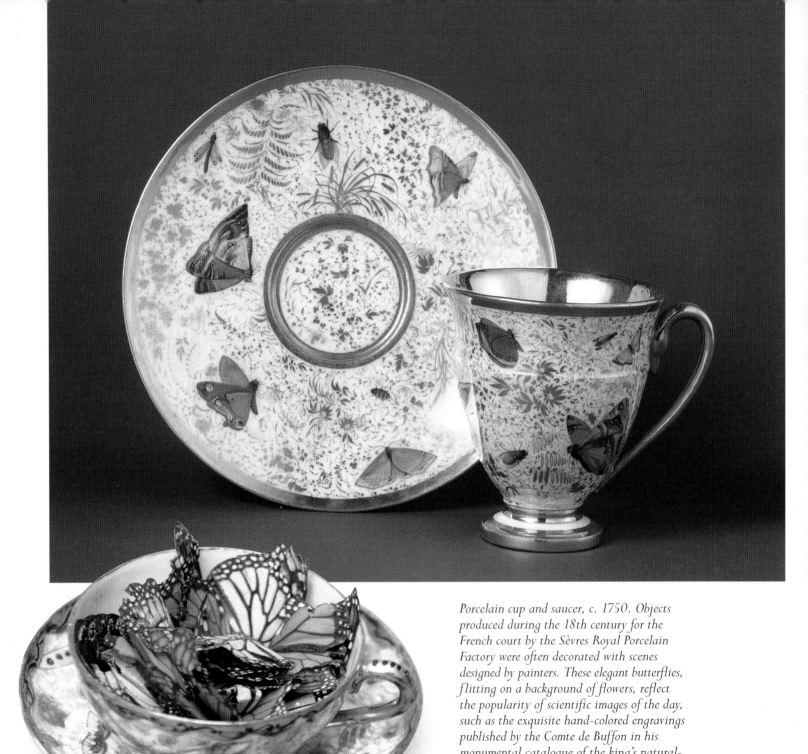

Porcelain cup and saucer, c. 1750. Objects produced during the 18th century for the French court by the Sèvres Royal Porcelain Factory were often decorated with scenes designed by painters. These elegant butterflies, flitting on a background of flowers, reflect the popularity of scientific images of the day, such as the exquisite hand-colored engravings published by the Comte de Buffon in his monumental catalogue of the king's natural-history collection. Musée National de la Céramique, Sèvres

This cup and saucer in the author's collection, a gift of Susan Lyons, is a perfect resting place for some of the dead butterflies found on the ground in the Valley of the Butterflies in Mexico.

Buffon himself is said to have painted realistic insect buttons much like these late-18th-century examples, which is painted in reverse and backed with a layer of white wax, surrounded by a gold border.

From an artist's point of view, butterflies and flowers make an attractive subject for decorative purposes, but a scientist would also link them, knowing that the pollination of plants is a vital function performed by butterflies as well as bees. As the butterfly sups on a flower's nectar, its legs, proboscis, and head gather pollen and carry it to the next flower.

The iridescence and splendid colors naturally occurring in butterfly wings have inspired the most talented artists to achieve fantastic effects with glass and gold.

RIGHT: *Tiffany & Company.* Enamel Box, *1900. Louis Comfort Tiffany's work in enamel is closely connected to his famous stained-glass designs, and he developed special techniques to produce luminous effects with gold foil under layers of translucent glass colors. Designs based on natural forms were particularly popular at the end of the 19th century, and the golden and iridescent colors of butterflies lent themselves admirably to Tiffany's experiments in this medium.*

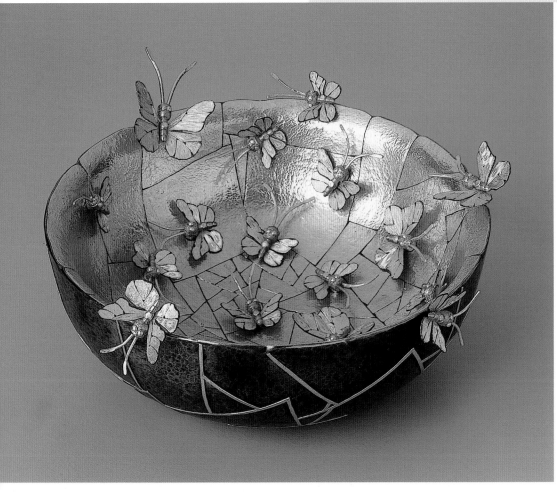

Daniel Brush. Butterfly Bowl, *1991–94. Gold, steel, and rare earth magnets. Brush has achieved remarkable effects by mastering and perfecting traditional jewelers' techniques. Here he has used pure gold to capture the lightness and delicacy of butterflies perching on a gold-lined bowl.*

Gold festoon necklace, 1805. This gold necklace features tiny micro-mosaic plaques of moths, similar to these late-18th-century buttons that reflect the fashionable demand for images inspired by archaeological discoveries of antique ruins in Italy. Victoria & Albert Museum, London

Late 18th-century Italian micromosaic button. The Roman artist Giacomo Raffaelli is credited with the invention of using tiny fragments of colored glass, or tesserae, to create micromosaics in the 1770s.

Since the beginning of time humans have decorated their bodies—to express their beliefs or status or identity, or just to look good. Jewelry has always been an intrinsic part of personal adornment, and butterflies have always been an important design inspiration.

ABOVE:
René Lalique. Comb, c. 1900. Union Centrale des Arts Décoratifs, Paris

OPPOSITE:
Henri Vever. "Sylvia" pendant,
c. 1900. Diamonds, rubies, and agate.
Union Centrale des Arts Decoratifs, Paris

These beautiful pieces from Van Cleef and Arpels demonstrate that diamonds can also be a butterfly's best friend.

Henry Blank and Co. Brooch, 1900. The Art Nouveau elegance of this piece of jewelry transforms a Victorian fairy into a butterfly goddess. Newark Museum

ABOVE:
Indian skirt, c. 1900. This Indian skirt is made of cotton and silk embroidered with tiny realistic butterflies in the border and odd butterfly-like creatures fluttering in the body of the fabric. The Metropolitan Museum of Art, New York, Gift of Mrs. Frances de Forest Stewart

LEFT:
Perhaps the butterflies decorating this beautiful 19th-century Chinese saddle rug added an element of lightness to the horse's feet. The Metropolitan Museum of Art, New York, Bequest of Joseph V. McMullen

RIGHT:
Butterflies play a purely decorative role in this 17th-century Persian textile, which is richly brocaded with satin velvet and gold-wrapped threads. The reliance on natural forms, which have been incorporated into a repeating pattern, reflects the taste of the Ottoman emperors who ruled Persia at the time this panel was made. University of Pennsylvania Museum, Philadelphia

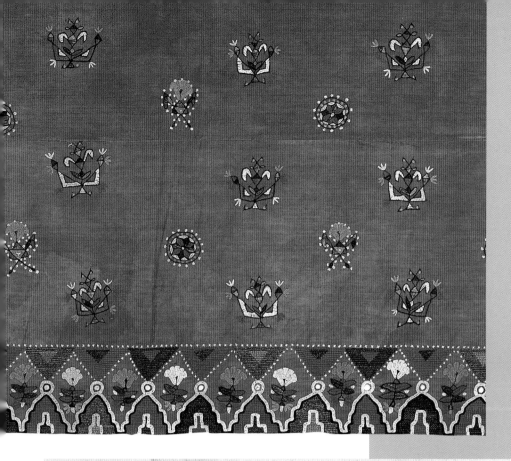

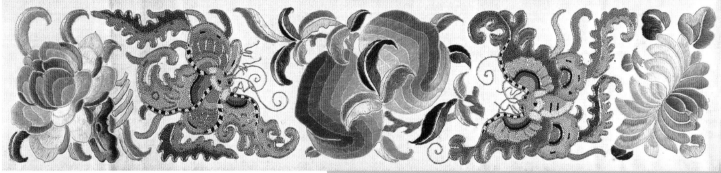

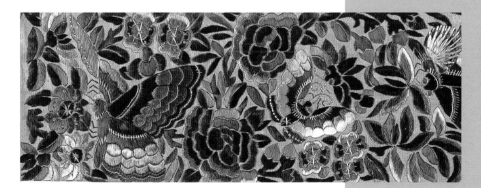

ABOVE AND LEFT:
Chinese sleeve bands, date. Like the wall hanging, these silk-embroidered panels used as sleeve bands combine floral and lepidopteran forms, but these images have been greatly stylized. Victoria & Albert Museum, London

FOLLOWING PAGES:
Unlike the naturalistic butterfly image in the Chinese painting on page 79, these butterflies, embroidered on a late 19th-century Chinese hanging, are schematic and nearly abstract, yet they capture the spirit of butterflies far more successfully. The Metropolitan Museum of Art, New York, Gift of Annette Young, in memory of her brother, Innis Young

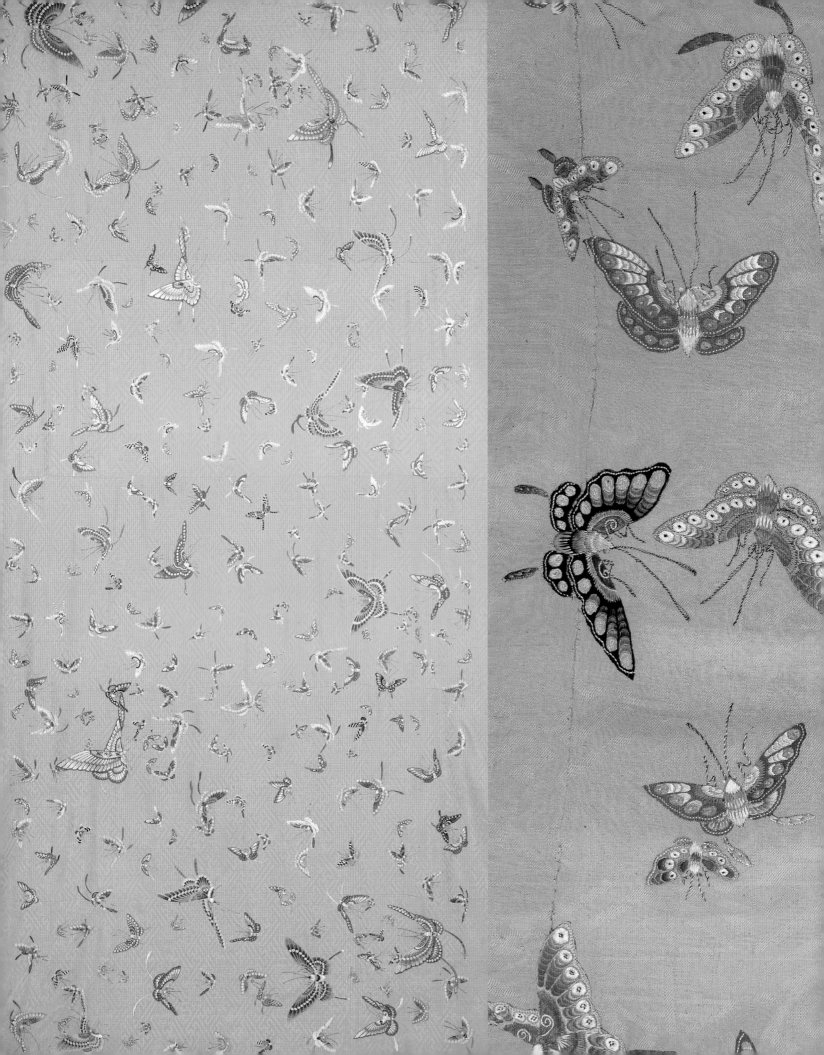

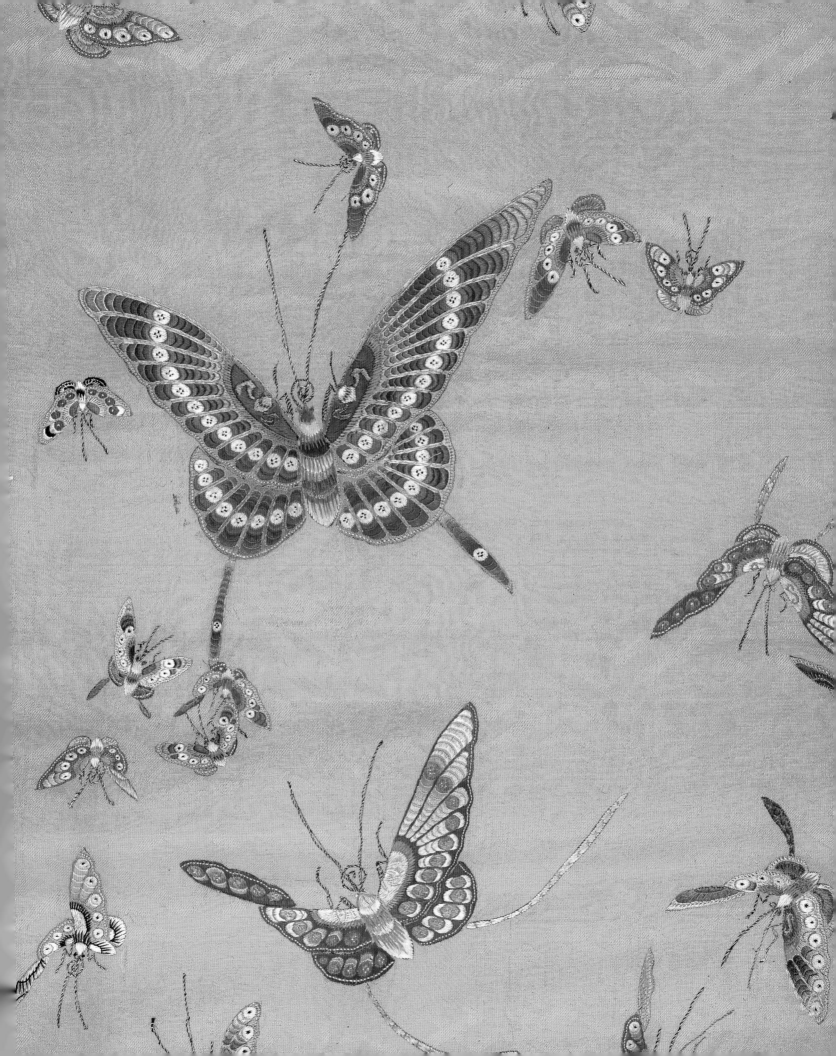

ABOVE:
This design for a textile painted in 1812–20 in France looks surprisingly modern and universal in its bold, abstract patterning. The Design Library, New York

OPPOSITE:
Anonymous American. Butterfly Quilt, 1930s. Quilt making is an old American tradition, a popular activity for women and an attractive way to liven up even the humblest interior. In spite of the advent of sewing machines and machine-made coverlets, quilting remains an important American craft, exemplified by this handsome quilt of the 1930s, the only period during which the butterfly appears on quilts to a great extent. Woodard & Greenstein American Antiques, New York

RIGHT:
Lace has played an important part in the history of apparel designed for both men and women, and various techniques were used to create elaborate handmade pieces, many of them commissioned by European royalty. As the demand for shawls, dresses, and veils became greater, lace manufacturers began to produce mostly machine-made objects, using traditional motifs, which included butterflies along with flowers and abstract patterns. This handmade Chantilly-lace butterfly was produced by the renowned French firm of Lefébure in the 19th century, perhaps as part of a mourning costume. Musée Baron Gérard, Bayeux, France

Lancaster print, 1856. Printed cotton textiles developed slowly in Europe, but the popularity of the printed materials imported from India eventually led to the invention of engraved metal roller printing, which allowed for the production of repeat patterns at a high speed. By the middle of the 19th century, the use of artificial rather than vegetable dyes made it possible for fabric mills to adopt a wide range of colors, ideally suited to the colorful subject of butterflies. Art Institute of Chicago

Pl. 15

*Eugène Seguy.
Design for a
fabric, 1930*

Bolivian rug, 20th century. Fine textiles have been produced in the Andes for thousands of years, and during the Incan Empire, were used to determine personal wealth and often to convey status and identity. This Bolivian rug, which incorporates a butterfly into its colorful weave, is a contemporary contribution to that tradition. Collection of the author. Gift of Shari Zisman

The richly decorated beadwork from the Huichol people of Mexico is very decorative, but it also contains many sacred symbols, including a sign of the peyote flower, as well as patterns similar to the classic mandala. Collection of the author

African fabric. The butterfly
perfectly embodies the
characteristics of beauty,
brightness, and joy reflected
in exuberant and vibrant
African fabrics. Butterflies
are inventively woven into
the designs draped on this
beautiful woman from Mali.

The designer of this
modern African print has
worked a stylized butterfly
into the overall design
of this handsome dress.
Collection of the author.
Gift of Naomi Lake

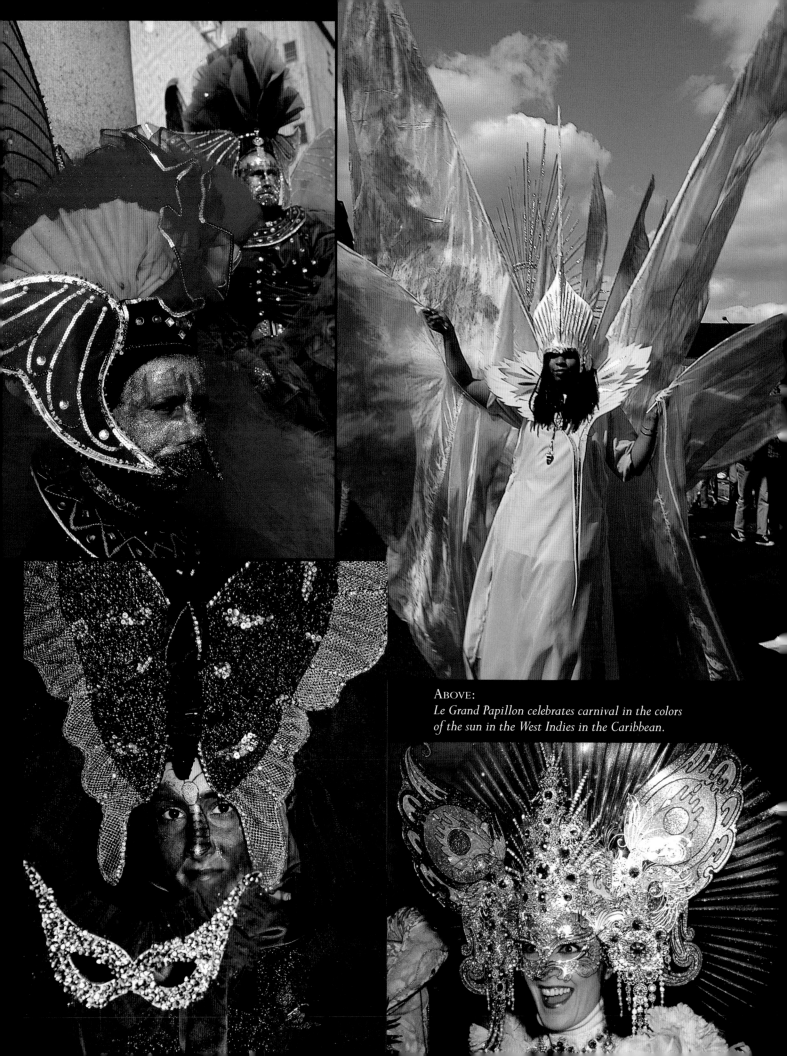

For millennia, an alternative form of body decoration has been tattoos, which are currently undergoing something of a revival. Butterflies have appeared discreetly on various parts of the body, but the butterfly tattoos worn by Huggy Bear Ferris, a tattoo artist, are not subtle ones. He wears more than a thousand butterflies among his 6,085 tattoos, each one in memory of a friend who has died since the Vietnam era, for he believes that when the body dies, the soul becomes a butterfly.

OPPOSITE, LEFT, ABOVE AND BELOW, AND BELOW RIGHT: *Venetian masks. The glamorous aspect of butterflies is captured in these fantastic masks at the Venice Carnival in most colors of the rainbow, if not of actual butterflies.*

Maraleen Manos-Jones. Reversible shawl from the Butterfly Goddess collection, made of velvet and crepe, with jet, glass, and sequin butterfly appliqués.

OPPOSITE:
Hanae Mori, an esteemed Japanese designer of haute couture that combines eastern and western influences, is known for her sumptuous wedding dresses designed for Japanese royalty and for the fashionable elite of New York and Paris. In Japan she is known as the Butterfly Lady of Fashion. She grew up in the countryside where the residents understood that butterflies signaled the arrival of spring and where fields of fragrant wild flowers were filled with fluttering colorful butterflies. These childhood memories inspired butterflies in many of her designs, and the images became her personal symbol of hope. Their fragility and beauty, she feels, is very much like fashion itself.

Jean-Philippe Worth. Ball Gown. European haute couture has also felt the effect of the butterfly's wings. The House of Worth dressed the most elegant ladies in late-19th-century Paris, where butterflies were all the rage, thanks to the popularity of Art Nouveau and the influence of Japanese art. Brooklyn Museum of Art, New York, Gift of Mrs. Paul G. Pennoyer

Thomas Maclean. E-Migration,
or a Flight of Fair Game, *1832.*
*In the early 19th century, the British
government encouraged unmarried
women to move to Australia, in order
to help stabilize the colony by boosting
the population. Thomas MacLean,
a political cartoonist of the era, used
migrating butterflies to poke fun at
this notion. Private collection*

*This postcard celebrating a drag-
queen parade in support of gay pride
certainly carries a powerful political
message. Butterflies are often used by
protestors and demonstrators, usually
in support of human rights and
environmental protection.*

*Nations use postage stamps to convey
a message, not always political. These
stamps from Hungary and Liberia are
decorative but they also speak to the
natural resources of the countries that
issued them.*

ABSOLUT CITRON.

*Cal-Oro Brand Orange County Valencias, Sunkist, c. 1930–40.
Oranges are hardly the most appealing element in this handsome
advertisement. Fine Arts Museums of San Francisco, Achenbach
Foundation for Graphic Arts*

TRADE MARK

*This cigar-box cover of about 1920
was inspired by Puccini's opera, which
enjoyed widespread popularity at the
time, although the audience had hissed
at its premiere in Milan in 1904.
Collection of the author*

ABOVE:
*Japanese matchbox, c. 1920.
As with the orange advertisement,
the butterfly images on this
matchbox have little to do with
their real content. Redstone Press,
London*

There was never a king like Solomon,
Not since the world began
For Solomon talked to a butterfly
As a man would talk to a man.

—Anonymous

The spirit of butterflies is everywhere among us, and yet it seems to have alighted with a particular intensity on certain individuals who have gone so far as to identify themselves with this most delicate and powerful of creatures. As we have seen, a Hopi clan has named itself for the butterfly, and in Japan certain families have taken the butterfly crest as their own, as part of their identity. A French family named Papillon has, of course, collected three butterflies on their distinctive coat of arms. Even Emperor Augustus in Rome adopted the butterfly image for his own emblem. Queen Rosaherina of Madagascar chose for herself the name Chrysalis, believing that her body was just the vessel for her soul, which would be released at her death, just as the butterfly emerges from its chrysalis. A woman who lived in a redwood tree in California for two years in order to convey her commitment to saving the environment has given herself the middle name of Butterfly.

Walt Whitman had a particular fondness for butterflies, and several images of butterflies appear with his papers that are on deposit at the Library of Congress, including a photograph of the poet with a butterfly (perhaps one of cardboard) perched on his finger. Among his notebooks this poem is inscribed on a hand-painted cardboard butterfly:

The first begotten of the dead
For us He rose, our glorious head,
Immortal life to bring.

What though the saints
Like him shall die,
They share their leaders' victory,
And triumph with their King.

Myth Two

Two caterpillars in West Africa were wandering through the tall grass looking for their favorite leaves when a beautiful butterfly fluttered overhead. One caterpillar was intrigued and in awe of the beautiful flying creature, while the other said that not for all the money in the world would he ever fly into the air like that. It was far too frightening. He felt that he belonged on the ground, safe and secure, with plenty of food, and that was where he was going to stay. The first caterpillar felt something stir in his heart when he saw the butterfly. He had an inner conviction that crawling on the ground was not his true nature. One day he would be up there, too, soaring with the birds and the butterflies.

After some time of crawling and eating and yearning, the caterpillar changed into a beautiful butterfly with strong wings and many bright colors, as he had dreamed all his life. But the other one stayed as he was, a caterpillar, crawling and eating leaves for the rest of his life because he never dared to dream or to know the meaning of his inner nature; he clung to what was familiar, what felt safe. He had no inkling of his true self. Only those who know their own true selves can soar like butterflies.

This Roman coin made during the time of the Emperor Augustus (reigned 27 B.C.–A.D. 14) shows his portrait on one side and on the other his emblems: a butterfly and a rose. The British Museum, London

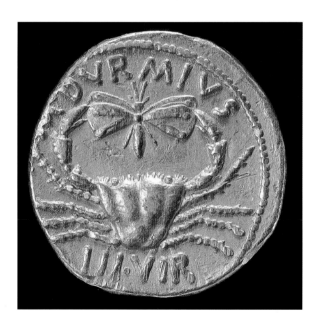

Opposite:
This photograph of Walt Whitman was made in 1880. He is holding a butterfly, probably the one reproduced below, a hand-painted image attached to a piece of cardboard on which he had written his poem "Butterfly." According to Alice Birney of the Library of Congress, Whitman, a tireless self-promoter, liked to convey the image of himself as at one with nature. The Library of Congress, Washington, D.C. Feinberg-Whitman Collection

Another important nineteenth-century figure who identified with the butterfly is James Abbott McNeill Whistler, whose mother's nickname for him was Butterfly and who in the mid-1860s began to sign many of his works and letters with a monogram made up of his initials in the form of a dragonfly that eventually evolved into a butterfly. The shape and form of the butterfly signature in letters varied according to the recipient; he sometimes added a scorpion's tail to emphasize the sting of his wit as well as the beauty of his art. Like many of his contemporaries, Whistler was inspired by Japanese art, which may have strengthened his admiration for this particular insect. A fine portraitist, designer, writer, and bon vivant, Whistler clearly felt that the butterfly with the sting in its tail was a powerful personal symbol, and so he was seen by others, including his friend the popular illustrator Walter Crane. Nevertheless, Whistler also worked the butterfly in a far more decorative, less intense way into some of his most appealing works of art, such as this portrait of Cicely Alexander and the painted doors of a mahogany cabinet designed by Edward W. Godwin. The influence of Japanese art is apparent on both works.

James Abbott McNeill Whistler signatures

Walter Crane, an English illustrator and contemporary of Whistler, caricatured his friend in 1908 using Whistler's own signature emblem. The New York Public Library, A. E. Gallatin Collection, The Miriam and Ira D. Wallach Division of Art, Prints, and Photographs; Astor, Lenox, and Tilden Foundations

James Abbott McNeill Whistler. The Butterfly Cabinet. Hunterian Art Gallery, University of Glasgow

James Abbott McNeill Whistler.
Harmony in Gray and Green, Miss Cicely
Alexander, *1872–74. Tate Gallery, London*

Maria Sybilla Merian was born into an artistic family in seventeenth-century Germany, and she was trained by her stepfather in the manner of the master Albrecht Dürer. By the time she was thirteen her artistic talent was well developed, but her passion for butterflies had just begun. Fascinated by their life cycle, she started raising silkworms and painting them, and she was so inspired by the process of metamorphosis that she began collecting caterpillars in order to observe their transformation into butterflies. She was a meticulous observer and a fine artist and by 1679, she had published her first book on European caterpillars, including information on origin, host plants, and all stages of metamorphosis. She discerned the difference between moths and butterflies and was aware that environmental changes affected the insects she studied. She published a second book on caterpillars in 1683.

After her stepfather died, she moved with her mother to a religious commune, where she had time to study and draw butterflies and other insects, specifically the exotic specimens brought back by missionaries from Surinam. She eventually moved to Amsterdam to continue her studies and at the age of fifty-two fulfilled her dream of going to Surinam, where she remained for two years until malaria brought her back to Holland. She published her magnum opus, *Metamorphosis Insectorum Surinamensium,* in Dutch and Latin in 1705. She died of a stroke in 1715, having inspired and informed many naturalists, including Carolus Linnaeus, who cited her work more than a hundred times, and Eleazar Albin who, in 1720, published an English book on butterflies. Merian's work caught the attention of Peter the Great, and in 1717 he purchased more than three hundred of her watercolors. The founder of the first natural-history museum in America, Charles Willson Peale, named his daughter after her.

LEFT:
M. S. Merian.
Flower Study with Butterfly, 1679.
The Fitzwilliam Museum,
Univeristy of Cambridge, England

RIGHT:
M. S. Merian. Golden Butterflies,
1679. The American Museum of
Natural History, New York

In Victorian England, another independent and adventuresome woman, Margaret Fountaine, discovered her own passion for butterflies and dedicated her life to them. Born in 1862 to a large family of modest means, she felt stifled by her mother's narrow view of the world. When she was fifteen, her father died, and it was at this point that she started to keep journals of her experiences. She was a happy young woman, with an extended family, and she enjoyed both an active social life and her talent for sketching cathedrals. An inheritance from a rich uncle enabled Margaret to escape from her mother, and at the age of twenty-nine she began to travel, devoting herself to the pursuit of butterflies in far corners of the world. Butterfly net in hand, she went bicycling across Italy, wandering through Hungary, trekking in Tibet, venturing through South Africa, Algeria, Turkey, Greece, Jamaica, the United States, and a great many places in between—on horseback, on foot, by train, aboard ship, or by dragoman.

Margaret Fountaine identified and mounted thousands of butterflies. She also became a photographer, and she painted and sketched butterflies, landscapes, and scenes of the many exotic places she visited. She died of a heart attack in 1940 at the age of seventy-eight by the side of a country road in Trinidad, her butterfly net nearby. Her collection of 22,000 butterflies, housed in ten mahogany cases with drawers of carefully labeled specimens, is displayed at the Castle Museum in Norwich, England. Along with her collection, she left a large black metal box with instructions that it was not to be opened until April 15, 1978, one hundred years after she started recording her life in diaries. Twelve thick identical volumes filled with her neat handwriting were found in the box, the journal in which she had confided her innermost thoughts and feelings and chronicled an extraordinary life in pursuit of butterflies and love. Excerpts were published in 1981 in a book entitled *Love Among the Butterflies.*

ABOVE AND BELOW:
Margaret Fountaine. Caterpillars/Chrysalis, *from her journals. The Natural History Museum, London*

The Avinoff/Shoumatoff clan traces the family's passion for butterflies back to 1830, but the one member of the family who was the epitome of the passionate lepidopterist was Andrey Avinoff, a gentleman-in-waiting to the last Russian tsar. Born in 1886, Avinoff became fascinated with butterflies when he was five years old; by eight he had started his own collection and by nine, he was painting butterflies accurately. When he left Russia for America in 1917, he had already collected 80,000 Central Asian butterflies, which he had to leave behind with his 7,000 entomological books. Educated by tutors, Avinoff was trained as a lawyer and diplomat at the University of Moscow, spoke seven languages, read ten more, and was knowledgeable in the fields of music, philosophy, art, art history, and entomology. He eventually became a masterful painter, incorporating his love and understanding of butterflies into his art, along with his broad knowledge of many cultures and his own inner vision.

Andrey Avinoff traveled extensively in pursuit of new species of lepidoptera. He and his nephew, Nicholas Shoumatoff, did pioneering work in Jamaica, collecting more than 14,000 specimens. He eventually became director of the Carnegie Museum of Natural History in Pittsburgh, where he brought artistry and accessibility to the then rather stodgy exhibits. His goal was to "inspire a sense of wonder before the boundless variety and the supreme unity of life." At the moment of his death, his good friend Blanche Matthias was taking a walk in the desert, far away, stretching her legs on a long ride, when she suddenly found herself surrounded by monarchs. She knew it was a sign. Later that day her premonition was confirmed when she was advised of Andrey Avinoff's death. Relatives recall that when he died in his hospital bed, a butterfly flew out of a vase of flowers in his room.

His sister, Elizabeth Shoumatoff, became a portraitist of the aristocratic and the wealthy. She did not paint or hunt butterflies but collected them in many artful guises, from her brother's paintings to teacups, napkins, matches, soaps, and much more. This poem, by Haniel Long, was one of her favorites and is said to have inspired Avinoff's triptych.

ABOVE:
Andrey Avinoff. The Dispensation of the Old and the New, *1947. Oil on canvas. Avinoff/Shoumatoff Family Collection*

> There will be butterflies
> There will be summer skies
> And flowers upthrust
> When all that Caesar bids
> And all the pyramids are dust
> There will be gaudy wings
> Over the bones of things
> And never grief
> Who says that summer skies
> Who says that butterflies
> Are brief?

In the triptych's central panel, moths, associated with the night, convey the twilight of the classics and the disintegration of the old order. Saint John stands on a precipice overlooking the Apocalypse, and a bat floats over the

Andrey Avinoff

scene, foreboding doom. A shepherd's crook lies abandoned in the foreground. In the right panel, materialism is represented by the dark skyscrapers with a *Parnassius autocrator* butterfly hovering over a lily, symbolic of majesty and associated with Juno, the Roman queen of heaven. When she was nursing Hercules, some of her milk splashed up to the sky, forming the Milky Way and some to the earth, creating lilies. The panel at the left depicts rebirth and resurrection, symbolized by the rose. Visible also are four images of Kuan Yin, the Chinese goddess of compassion. The snowflakes give us a glimmer of awareness and awakening, and a rainbow bridges the old culture and the new, honoring all wisdom. The new world, having let go of the old decay, now embraces hope. The emperor moth and the *Chrysiridia madagascarensis,* an African species, are a dominant and integral part of the awakening panel.

Literature and butterflies are the two sweetest passions known to man.
— *Vladimir Nabokov*

Enthusiasm for butterflies was a constant in the life of this eminent Russian writer, critic, philosopher, poet, lecturer, translator, teacher, and avid entomologist who managed to bridge the gap between science and art. Vladimir Nabokov not only collected and wrote about butterflies extensively; he is one of the very few people who have eaten butterflies. He tasted both the monarch and the viceroy to see if he would be poisoned (he wasn't). In his autobiography, *Speak Memory,* Nabokov wrote: "From the age of seven, everything I felt in connection with a rectangle of framed sunlight was dominated by a single passion. If my first glance of the morning was for the sun, my first thought was for the butterflies it would engender. On the honeysuckle, overhanging the carved back of a bench just opposite the main entrance, my guiding angel. . . pointed out to me a rare visitor, a splendid, pale-yellow creature with black blotches, blue crenels, and a cinnabar eyespot above each chrome-rimmed black tail. As it probed the inclined flower from which it hung, its powdery body slightly bent, it kept restlessly jerking its great wings, and my desire for it was one of the most intense I have ever experienced."

Nabokov's aristocratic family had to leave Russia as the Bolshevik Revolution began. They emigrated to the Crimea and then Greece and England before settling in Germany, where they lived until 1940, when Nabokov, with his wife and son, moved to France before emigrating to the United States. He was fluent in Russian, French, and English and wrote several brilliant novels, the most famous of which is *Lolita.* He also traveled all over the world searching for new species of butterflies. He was obsessed with capturing their beauty, identifying nuances in what were once thought to be a single species, and he thrilled in discovering new species. He was a pioneer in the field of identifying butterflies, not only by their markings, but also by dissecting them and studying their anatomy, particularly the genitalia.

Nabokov collected tens of thousands of moths and butterflies, and he had the pleasure of naming numerous butterflies and having butterflies named after him or characters from his work, among them *vokoban* (Nabokov in reverse), *vera, lolita, humbert, ada,* and *zembla.* In 1955 Nabokov's blue, also known as the Karner blue, was named after the writer, since he had done extensive research into this group of butterflies (see next page). He bridged his dual obsessions, literature and butterflies, and wrote extensively throughout his life in scientific journals, as well as alluding to lepidoptera in his writings. He dedicated his work to his beloved Vera, his wife and partner, for whom he drew half-fanciful, half realistic butterflies.

Another Russian with a passion for butterflies was Sergei Khrushchev, son of the late Nikita Khrushchev. While the father was banging his shoe at the United Nations in 1956, the son was on an outing in Brooklyn collecting butterflies. Now, some fifty years later, the son has become an American citizen and teaches at an American university.

Nabokov and his wife hunting butterflies. New York Public Library

BELOW:
Nabokov's drawing of a butterfly reproduced on the flyleaf of the screenplay edition of Lolita, *1974*

LOLITA
A SCREENPLAY

Verinia lolita cinemathoides

April 1974

Photograph of the butterfly parade in the town of Pacific Grove, California

At least two towns in the United States could be said to be passionate about butterflies, although they express their love in very different ways. Pacific Grove on the Monterey peninsula in California is the destination for monarch butterflies that migrate in the fall west of the Rockies. Here, about 25,000 to 100,000 monarchs hibernate each winter. This is a much smaller population than the one in Mexico, but it is magnificent nonetheless. The whole town has adopted the monarchs and is very protective of them. Molesting a monarch is a misdemeanor in Pacific Grove. Half a dozen bright orange signs line the town's roads reading "Caution: Butterfly Zone." There are Monarch Hotels, shops, and school projects. Every October the schoolchildren dress up as butterflies and have a parade to welcome the butterflies as they arrive.

In 1992 a small, lovely, iridescent blue butterfly, the Karner blue (named for Vladimir Nabokov, who studied them extensively) made the United States endangered-species list. It has almost disappeared from Ohio, Maine, and Pennsylvania, largely because of the widespread loss of the wild blue lupine on which it depends. At the time, a small town in the Adirondacks, West Wilton, New York, was going through difficult and changing times. The construction of a new interstate highway in the 1970s had brought rapid expansion, complete with malls and tract housing, but even the pro-development forces in town eventually realized that they were losing the very essence of the quality of rural life.

In due course, the town decided to act on behalf of its own future by creating a wildlife preserve to protect meadows of wild blue lupines, which satisfy the appetites of Karner blue butterflies. Townspeople deeded family fields and woods to the Wilton Wildlife Preserve and Park, businesses pledged protection and donated needed materials, the Nature Conservancy became involved, and private donations began to accumulate. Schools have become involved, and each spring the children are given wild blue lupine seeds and are encouraged to plant them in their own butterfly gardens. With the whole community involved, the town has accomplished a major change of direction, one that will provide enjoyment and tranquility for residents and visitors, sustenance to many wild species, and the gift of life itself to the Karner blue.

The Verbal Butterfly

Not surprisingly, it is possible to say *butterfly* in many different languages:

Aboriginal	banjalahm, bataplai, malimali, pilyu-pilyuka, among others	**Hawaiian**	pulelehua, lepelepe-o-hina
Afrikaans	skoenlapper	**Hebrew**	keshet, parpar
Albanian	flutur	**Hmong**	npau npaim
Anglo Saxon	fifoldara	**Hungarian**	lepke, pilango, or pillangok (pl)
Arabic	farasha, abu daqeek	**Icelandic**	
Balinese	kupukupu	(Old Norse)	fidrildi
Bulgarian	peperooda	**Indonesian**	kupu-kupu
Cherokee	kamama	**Irish Gaelic**	feileacan
Chinese	he die	**Indonesian**	kupu-kupu
Czech	motyl	**Irish Gaelic**	feileacan
Danish	summerflugl	**Irish** (Breton)	maro (and Death Goddess)
Dutch	kapel, vlinder	**Italian**	farfalla
English	butterfly	**Japanese**	cho, chocho
Middle English	buterflie	**Jamaican**	bots
Old English	buterfloege, fifalde	**Korean**	nabi
Esperanto	papilio	**Kwoma**	
Estonian	liblikas	(Papuan)	aposiibiiruka
Ethiopian (Amharic)	buraburay	**Laotian**	meng kabeua
Finnish	perhonen	**Latin**	papilio
French	papillon	**Lithuanian**	petaliske
German	schmetterling	**Malaysian**	pappa hi, rama-rama
Old German	fifaltra	**Maori**	kaakahu kura, kahukura, mookarakara, peepepe
Ghanian	aflikilo	**Moroccan**	
Greek	petalouda	**Arabic**	bouffertouton
Greek (ancient)	psyche	**Nahuatl**	papalotl
Greek		**Nepali**	putali
(German and Slavic)	mora, mara, or morava (and nightmare)	**Norwegian**	sommerfugl

Persian	parvani
Philippine	paro paro
Polish	motyl
Portugese	borboleta
Punjabi	bahman bacca
Romanian	fluture
Russian	boboochka, dushichka
Serbo-Croatian	
	leptir
Slovak	veja
Spanish	mariposa (La Santa Maria posa)
Sri Lankan	samanalaya sinhala
Swahili	kipepeo
Swedish	fjaril
Taiwanese	ya-a
Thai	meng peeseua
Tibetan	cemcema
Turkish	kelebek
Ukrainian	metelyk
Urdu	titli
Vietnamese	con burom, buom buom
Welsh	gloyn byw
Yiddish	zomerfeygele
Zulu	vemvane, abajuhane, twabitwabi

And the word *butterfly* itself has also been used to mean many things other than lepidoptera. In 1999, for instance, the papillon breed of dog won best in show at the Westminster Kennel Club show. There are also tropical butterfly fish and butterfly trout. Gastronomically there are butterflied shrimp, butterflied leg of lamb, a Madame Butterfly sushi roll at the Japonica Restaurant in New York, and butterfly cookies from Dean & Deluca and Balthazar's; Martha Stewart even has butterfly cookie cutters in her catalogue. For the sports-minded, we must not overlook the butterfly stroke in swimming and fishing with butterfly nets (in Lake Patzcuaro, Mexico), and butterfly kissing with eyelashes. Botanists have named a species of flower the whirling butterfly (*Gaura lindheimeri*), and astronomers know well the Butterfly Nebula. Butterflies have also inspired writers, from William Goldman's only play *The Brass Butterfly* to Hungarian novelist Zsigmond Moricz's *Butterfly* (1925). It is perhaps in the cinematic domain that butterflies reign supreme, with more than eighty-seven movies named "Butterfly" or some variation thereof, starting in 1910, and many more called "Papillon," including the famous 1973 Steve McQueen film in which he played the title role of a convict on Devil's Island in French Guiana. His nickname, Papillon, came from his tattoo but also from his ability to escape from prison.

Feeling butterflies in one's stomach is practically a universal metaphor for feeling nervous, just the opposite of "Float like a butterfly, sting like a bee," a credo devised by aide Drew "Bundini" Brown and made popular by that master of confidence Mohammed Ali.

For the etymologists (and entomologists) among us, a rhopalocerist is one who studies diurnal lepidoptera, or butterflies, while a heterocerist studies nocturnal lepidoptera, or moths. A woman who appears with butterfly wings in literature or art is called a rhopalocerienne, and presumably a woman with the wings of a moth is called a heterocerienne.

The Fragile Butterfly

The butterflies—what an educated sense of beauty they have. They seem only an ornament to society, and yet, if they were gone, how substantial would be their loss.

—*Phil Robinson*

Butterflies have been on our planet for about 75 million years, and they inhabit every continent except Antarctica. In all, there are about 17,000 species of butterflies and 140,000 species of moths known at this time, most of them occurring in latitudes between fifty degrees south and seventy degrees north of the equator. The most numerous and diverse species, however, reside in two vast areas of our planet: along the eastern slopes of the Andes Mountains in Peru, Colombia, Venezuela, and the upper Amazon of Brazil, and in Asia, from New Guinea, Indonesia, and Malaysia up to Bhutan in the Himalayas.

With these numbers, one might question the concern that environmentalists have for the future of the butterfly. However, lepidopterists feel that butterflies are the present-day canaries in the mines, sensitive indicators of trouble in ecological systems, whether because of toxins in the environment, introduced plant species that disrupt the ecology, genetic tampering, or general habitat destruction. It is obvious that pesticides targeting insects will also kill butterflies, but so will herbicides that eliminate weeds on which butterflies rely. For example, recent studies have shown that milkweed is being eliminated from the corn belt of the American Midwest, a major breeding ground for the monarch butterfly, and corn genetically altered to include pesticides is also threatening the monarch's survival. Many millions of acres are being planted with this type of corn, and the federal government is about to approve

Hashime Murayama. Migration, *1935. National Geographic Society*

Andy Warhol. San Francisco Silverspot,
Endangered Species Series, 1983.
The Andy Warhol Foundation for the Visual Arts

genetically altered potatoes and cotton. Careless rather than deliberate destruction is resulting in such phenomena as global warming, which is forcing numerous butterfly species to move toward the poles and higher altitudes. This cannot help but affect the pollination and survival of host plants, whose destruction in turn can wipe out species of butterflies.

There are about twenty-five butterflies on the endangered species list of the United States Fish and Wildlife Service, most of them put there because of loss of habitat through construction, overgrazing, logging, and the pollution of air, earth, and water. Andy Warhol made a series of lithographs of endangered species and chose the San Francisco Silverspot to represent the butterfly.

Myth

A friend from Trinidad shared the following anecdote, the title or origin of which he did not know, but he had heard it when he was a young boy and had always remembered it.

Once upon a time, a young boy and his father were walking through a flower-filled field. To the young boy's amazement, he saw the most beautiful colors, ever so many, moving in the bush. He was so excited he ran quickly ahead of his father and all of a sudden when he got close, he just stopped in his tracks. The little boy said, "Daddy, Daddy, come here quickly, look at this and please tell me what are all these beautiful colors?"

"Son, this is a butterfly coming out of a cocoon." "But, Daddy, look, see how it is suffering. It's struggling so hard, can I help it please?" "No, son, the way we are going to help that butterfly is that we are going to sit here and make sure nothing happens to it. We are going to protect it." They sat there for some time and then the little boy said, "But, Daddy, it's struggling so hard. Why must it suffer like that?" The father said, "Calm down, everything is the way it should be."

They waited a little longer and the little boy couldn't hold his emotions anymore and begged his father to let him help it. "No, son. But I'll tell you what. I have to go back into town, but I need you to stay here and just watch this butterfly and make sure when harm comes, it is not in harm's way." The little boy solemnly agreed and the father left.

The little boy sat there looking closely at that butterfly and the more he looked, the more the butterfly struggled to get out of the cocoon, and the more magnificent were the shades of colors unfurling. The colors were so breathtaking he could hardly believe his eyes. The more he watched this poor butterfly's efforts, the more he felt like crying.

At last, the little boy couldn't take it anymore. He defied his father's wish. He went over to the branch and he picked up the cocoon, grabbed the beautiful colors and started to pull. At first, when he began to pull, he started seeing more beautiful colors. At a certain point, the more he pulled, the more the colors began to fade until finally the colors turned gray. When the butterfly fully emerged, one-half was a rich rainbow and the other half was gray.

The little boy began to cry. And when the father came back and saw his son crying, he wanted to know what happened. The little boy slowly opened his hand, finger by finger. As he lifted the first two fingers, the father was dazzled by the colors. The boy continued lifting the other fingers, sadly looking up at his father until the gray undeveloped butterfly was exposed.

Butterfly Gardens

To me a garden is dead—no matter how many birds it has, no matter how well kept the grass and flowers—if it has no butterflies.
—Bernard D'Abrera, Australian entomologist and photographer

As people become more aware of and interested in butterflies, they learn not only to identify species but also to discover what kinds of plants the butterflies need as a source of nectar and as host plants for their larvae. This quickly leads to an interest in gardening and learning which plants are likely to attract butterflies at different stages of their lives. Soon one becomes familiar with plants indigenous to a particular geographical area and becomes concerned about maintaining or restoring some semblance of natural habitat. And that, presumably, results in a concern for the planet as a whole.

Happily, there are now millions of enthusiasts who design and maintain their gardens to attract butterflies, and their numbers increase daily. In 1946 Sir Winston Churchill created a butterfly garden at his Chartwell estate in Kent, England, where fifteen hundred butterflies were hatched each year, including peacocks, tortoise-shells, brimstones, commas, red admirals, painted ladies, and clouded sulphurs. This garden was his retreat from the world, a place where he had the time and space to reflect and to indulge his lifelong fascination with butterflies. He planted magnificent flowers to attract and feed both caterpillars and butterflies, and each spring he had thousands of butterflies brought in to his butterfly house, where he raised them and watched them undergo their transformation. Three years after Churchill's death in 1968, a butterfly conservation foundation was established to his honor his lifelong passion and fascination with butterflies.

Since most of us do not have huge estates, we create our gardens in backyards or rooftops, and even on fire escapes and in window boxes. If you know what butterflies like, you can create a butterfly garden no matter where you live or what space you have. Even suburban gardeners have come to realize that lawns—homogenous, manicured, and flowerless—are lifeless places despised by butterflies and other insects, but even a lawn can be easily converted into a butterfly habitat with the addition of a few well-chosen plants. Because these plants tend to have beautifully colored blooms that smell wonderful, butterfly gardens are also attractive to people. It has been

Arthur Okamura. Butterfly Tree, 1967. Etching. Fine Arts Museums of San Francisco, Achenbach Foundation for Graphic Arts, Gift of Ruth S. Steiner, Jean S. Engleman, and Marian A. Stinton in memory of Mr. and Mrs. Edgar Stinton

found that butterflies will choose one type of flower one year and another the next, or they may choose your neighbor's flowers over yours, for no apparent reason. Multiple environmental factors can affect their choice: soil chemistry, wind direction and velocity, light intensity, and time of day. There are many excellent butterfly gardening books, useful sites on the Internet, and butterfly-watching and conservation groups, and nearly every commercial nursery now has a section devoted to plants that attract both caterpillars and butterflies.

Butterfly gardens provide a practical means by which individuals can help save habitats and species, but they also have the power to touch souls and transform them. Garden clubs have enthusiastically embraced growing flowers for butterflies; in Florida, the Federation of Garden Clubs encourages individuals and groups to plant butterfly-friendly gardens by issuing Butterfly Sanctuary Certificates. Participants agree to follow certain guidelines, such as making sure that there are host plants for caterpillars and nectar plants for butterflies, and they also agree not to use harmful chemicals. Public-garden participants agree to develop educational programs about butterflies in nature, and many of these sanctuaries sell or give away plants needed by local butterflies.

Many schools are now involved in the Butterfly Sanctuary project, and the programs reach thousands of children, including groups of handicapped or emotionally troubled children, who do research, plant gardens, and observe butterflies going through metamorphosis. The children create art and poetry through which they learn to respect all living things and to appreciate the mystery and magic of life.

Cecil B. Day Butterfly Center, Calloway Gardens, Georgia

If you cannot keep your own butterfly garden and want to experience a butterfly up close and in person, there are now hundreds of lepidopteria or vivaria or insectoria filled with butterflies flying free in a tropical or semitropical environment. (The National Zoo in Washington, D.C., even has a pollinarium full of honeybees and hummingbirds, as well as butterflies.) The first lepidopterium, Worldwide Butterflies, opened in 1978 in Compton House, near Sherborne in Dorset, England, and immediately became very popular. Ten years later, the first live butterfly exhibit opened in the United States, the Cecil B. Day Butterfly Center at Calloway Gardens in Pine Mountain, Georgia, quickly followed by Butterfly World in Coconut Creek, Florida, a tropical atrium environment in which classical music accompanies the sounds of a waterfall splashing, the cooing of doves, and the rustling of butterfly wings.

Even in the urban north, it is possible to experience butterflies year round. In the summer, the Bronx Zoo, operated by the Wildlife Conservation Society, opens its Butterfly Zone exhibit, housed in a tent shaped like a huge caterpillar and featuring numerous examples of species native to the United States, many of them to New York. (All are raised on butterfly farms, incidentally, and not in the wild, and in the winter, when the exhibit is closed for the season, the remaining butterflies and chrysalids are taken to the zoo's Jungle World exhibit to live out their retirement.) The American Museum of Natural History takes up the butterfly slack in winter with its Vivarium, which features about three to five hundred butterflies representing about thirty tropical species from Florida and Costa Rica.

Most lepidopteria have glass display cases containing chrysalids, so the public can view the birth of butterflies. It is in this state of outward stillness that thousands of chrysalids can be most easily transported to continue their metamorphosis in the public's eye from the butterfly farms where they were raised. There are more than two dozen large butterfly farms in Malaysia, Taiwan, and Costa Rica, and hundreds of smaller butterfly farmers in the United States help to supply the continually growing numbers of butterfly habitats around the world. And this, in itself, might help save butterflies and their habitats, although, of course, problems present themselves. Butterfly farming has become a big business, with more than a billion dollars a year at stake. Ten years ago, when there were only a few lepidoptera, the demand was mostly for school projects and individuals, but now hundreds of butterflies may be ordered at a time for the butter-fly exhibits and for other purposes, some of them controversial, such as the releasing of butterflies for special occasions, including not only weddings and memorial ser-vices, but also for cancer-support groups, bar mitzvahs, divorces, and prison releases.

Many people feel that the release of butterflies captures the beauty and poignancy as well as the spirit of certain occasions, but conservationists and professional and amateur lepidopterists argue that this habit of shipping and releasing butterflies disturbs behavior patterns and may result in the spread of disease and the upsetting of ecological balance. Release of hundreds of non-native butterflies could cause inappropriate mixing of genetics and mass confusion for migrants, and it might also confuse the scientific tracking of migrating and local species.

Conservationists would rather encourage people to join the growing number of butterfly-watching groups, where the thrill is in spotting different species in their natural environments and in helping keep track of the health of native populations by providing annual butterfly counts.

The effect of a butterfly's wing can be felt around the world.
—Anonymous

The unidentified author of this famous remark chose the butterfly to illustrate the power of small, seemingly innocuous actions to bring about change on a grand scale, to demonstrate how everything we do ripples out to the rest of the universe.

The idea that the flapping of a butterfly's wings in one part of the world can set off a chain of events that might lead to a hurricane in another area is far more credible nowadays. We have all become painfully aware of our interconnectedness, that what happens in a far-off country can disrupt our lives in many ways, from the spread of mysterious deadly viruses and terrorist tactics to the impact of worldwide financial markets and the interchange of cultural values.

I believe that the butterfly effect can also be used to awaken us to the fragility of life as we know it, to remind us to take care not to destroy the planet before it is too late. As we have seen, peoples of many cultures throughout history have observed and been profoundly moved by the process of the butterfly's meta-morphosis, which plucks a universal chord and reminds us in whispers that life is a cycle: it never ends, it just changes from one form to another, some forms more beautiful than others.

Human carelessness has resulted in destroyed forests and polluted oceans, but the spirit of the butterfly teaches us that no matter how many times the gardens of our lives or planet are destroyed, we can replant, rebuild, and renew.

What I have tried to capture in this book is the essence of butterfly spirit in the hope that it may tickle, touch, and awaken the Great Spirit within all of us. Every thoughtful act we perform that is filled with light, compassion, respect, or love can have as profound an influence as our destructive impulses, as effective as the fluttering of a butterfly's wing. The very survival of our planet may depend on this awakening, this shift of attitude from the dark side to the light that leads us on another step in our spiritual evolution.

Maraleen Manos-Jones. Butterfly Spirits Enter My Garden, *1998. Collection of the artist*

Bibliography Sources

Berger, Joseph. "Mystique of a Butterfly Stirs the Soul of a Town," *New York Times,* January 14, 1999.

Berlo, Janet Catherine, "The Warrior and the Butterfly: Central Mexican Ideologies of Sacred Warfare and Teotihuacan Iconography," in *Proceedings 44 of Congreso Internacional de Americanistas,* Norman Hammond, ed. (1982).

Beutelspacher, Carlos R. *Las Mariposas Entre Los Antiguos Mexicanos,* Mexico City: Fondo Cultura, 1988.

Carroll, Sean. "Genetics on the Wings: Or How the Butterfly Got Its Spots," *Natural History* (February 1997).

Castaneda, Carlos. *Tales of Power.* New York: Washington Square Press, 1992.

Children's Drawings and Poems from Terezin Concentration Camp 1942-44. New York: Schocken Books, 1978.

Cooper, J. C. *Dictionary of Symbolic & Mythological Animals.* New York: Harper Collins, 1992.

Denker, Eric. *In Pursuit of the Butterfly: Portraits of J. M. Whistler.* Seattle: University of Washington Press, 1995.

Donaldson, I. *Moons of Long Ago: How Butterflies Came.* New York: Olcott, 1922.

Enciso, Jorge. *Design Motifs of Ancient Mexico.* New York: Dover, 1953.

Erdoes, Richard, and Alfonso Ortiz. *American Indian Myths & Legends.* New York: Pantheon, 1984.

Estes, Clarissa Pinkola. *Women Who Run With the Wolves.* New York: Ballantine Books, 1992.

Fasoranti, J. O. *The Food Insects Newsletter,* vol. 10, no. 2, published by the University of Ilorin, Nigeria (July 1997).

Fewkes, J. Walter. "The Butterfly in Hopi Myth and Ritual," *American Anthropologist* 12 (1910).

Fountaine, Margaret. *Love Among the Butterflies.* Boston: Little, Brown, 1980.

Gaster, M. *Rumanian Bird and Beast Stories.* London: Sidgwick & Jackson, 1915.

Gimbutas, Marija. *Goddesses and Gods of Old Europe, 6500–3500 B.C., Myths and Cult Images,* rev. ed. (Berkeley, California, 1982)

Gimbutas, Marija. *The Language of the Goddess.* San Francisco: Harper Collins, 1991.

Hadland, David F. *Myths and Legends of Japan.* London: G. G. Harrap, 1913.

Haile, Bernard. *Love Magic and Butterfly People.* Flagstaff, Ariz.: Museum of Arizona Press, 1978.

Heh, Charlotte. *Native American Dance Ceremonies and Social Traditions.* Washington, D.C.: Smithsonian, 1992.

Johnson, Buffie. *Lady of the Beasts.* Rochester, Vt.: International Traditions, 1994.

Kübler-Ross, Elisabeth. *The Wheel of Life: A Memoir of Living and Dying.* New York: Touchstone, 1997.

Lehner, Ernst. *Symbols, Signs & Signets.* New York: Dover, 1950.

Levitas, G., Fr. Vivelo, and J. J. Vivelo. *American Indian Prose & Poetry.* New York: Putnam, 1974.

Macy, Ralph W., and Harold H. Shepard. *Butterflies.* Minneapolis: University of Minnesota Press, 1941.

Nabokov, Vladimir. *Speak Memory.* New York: G.P. Putnam's Sons, 1966.

Nicholson, Irene. *Firefly in the Night: A Study of Ancient Mexican Poetry and Symbolism.* London: Faber & Faber, 1959.

Nicholson, Irene. *Mexican and Central American Mythology.* London: Hamlyn, 1967.

Obligato, George. *The Magic Butterfly & Other Fairy Tales of Central Europe.* New York: Golden Press, 1963.

Patterson, Alex. *Hopi Pottery Symbols.* Boulder: Johnson Books, 1994.

Peigler, Richard S. "Non-Sericultural Uses of Moth Cocoons in Diverse Cultures," *Proceedings of the Denver Museum of Natural History,* ser. 3, no. 5 (1994).

Ross, Gary Noel. "Butterfly Magic," *Wildlife Conservation* (August 1996).

Rothschild, Miriam. *Butterfly Cooing Like a Dove.* New York: Doubleday, 1991.

Sandved, Kjell B., and Jo Brewer. *Butterflies.* New York: Harry N. Abrams, 1978.

Sandved, Kjell B., and M. Emstey. *Butterfly Magic.* New York: Penguin Books, 1976.

Schnock, Friedrich. *The Life of the Butterfly.* Trans. by Winifred Katzin. London: Allen & Unwin, 1932.

Sejourne, L. *Burning Water: Thought and Religion in Ancient Mexico.* San Francisco: Shambala, 1976.

Shoumatoff, Alex. *Russian Blood.* New York: Vintage Books, 1990.

Soustelle, J. *Daily Life of the Aztecs.* Stanford, Calif.: Stanford University Press, 1978.

Stevens, William K. "Western Butterfly Shifting North as Global Climate Warms," *The New York Times,* Sept. 3, 1996.

Volavkova, Hana, ed., *I Never Saw Another Butterfly: Children's Drawings and Poems, Terezin, 1942–44.* New York: Schocken, 1978.

Wang, Mei. *The Butterfly and Other Stories.* Beijing: Panda Books, 1983.

Wasson, R.G. *The Wondrous Mushroom.* New York: McGraw Hill, 1980.

Weed, Clarence. *Butterflies Worth Knowing.* Garden City: Doubleday, Page, 1917.

Wetteng, Kurt. *Maria Sybilla Merian, Artist & Naturalist.* Stuttgart: Gerd Hatje, 1998.

Wyatt, Patricia. *Keepers of the Dream.* Rohnhert Park, Ca.: Pomegranate Art Books, 1995.

Yoon, Carol. "For Butterflies, A Promise of Peace With Truckloads of Trees," *New York Times,* Aug. 25, 1998.

Yoon, Carol Kaesuk. "Festive Release of Butterflies Puts Trouble in the Air," *New York Times,* Sept. 15, 1998.

Yoon, Carol Kaesuk. "On the Trail of the Monarch, With the Aid of Chemistry," *New York Times,* Dec. 29, 1998.

 Page numbers in *italics* refer to illustration captions.

Acknowledgments

I would like to thank the following: my editor, Barbara Burn, whose guidance, enthusiasm, and expertise helped me shape my vision into this book; Carol Robson, for her truly special and creative book design; my husband, Stephen M. Jones, for his support and for sharing our home with butterflies; Elisabeth Scharlatt, the godmother of this book, for believing in me all these years; Shari Zisman, for her readings and feedback; the Shoumatoff family, for sharing their stories and opening their library to me; Elton Harris, an excellent and meticulous photographer with a calm and helpful demeanor; Richard Peigler, for sharing his cocoon stories; Clarissa Pinkola Estes, for allowing me to include one of my favorite stories; Carlos Beutelspacher, for sharing his research and allowing me to reproduce his wonderful images; the estate of Marija Gimbutas, for allowing me to include her valuable research; Darrell Beasley, for his creative ideas; Dana Loprieno, my hero in times of computer crises; Sandro Giuliani, Ronna Texidor, Ann Marie Davies, Lisa T. Bright, Susan Lyons, and Katherine Silverii for their support and assistance in so many ways; and to the knowledgeable and friendly staffs of the many museums and libraries I visited, without whose help my research would have been more difficult.

Photo Credits

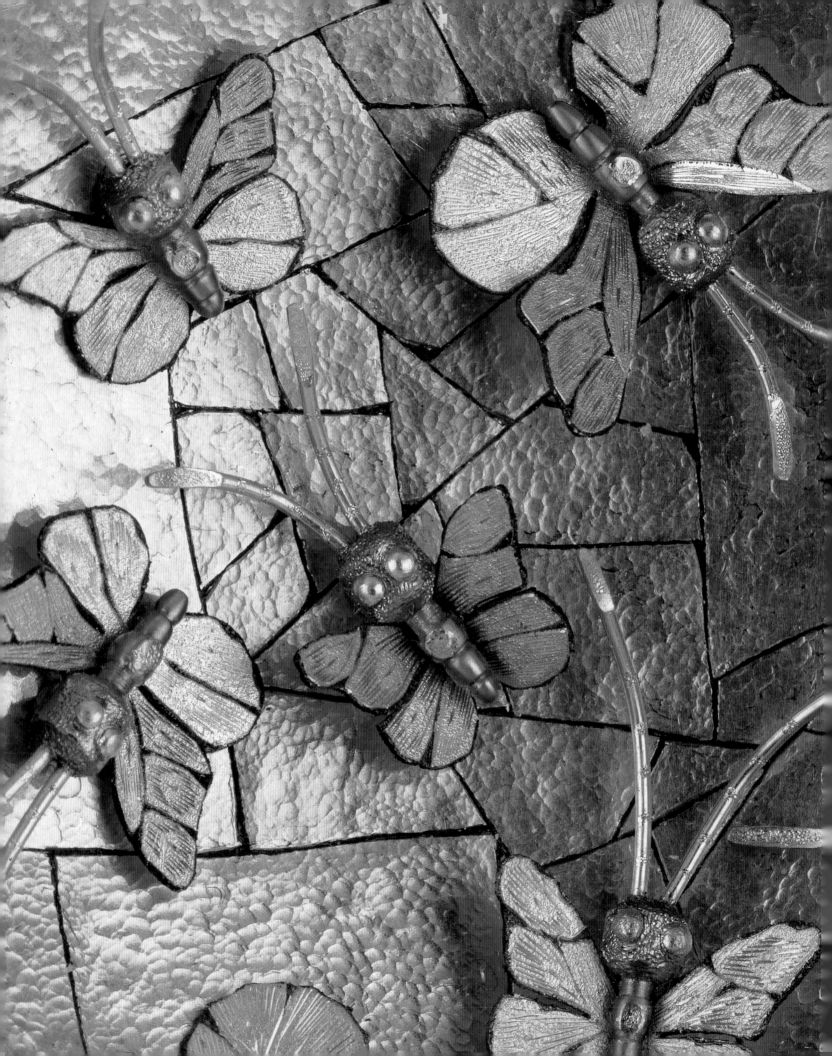